GIO_GRAPHY
Fun in the Wild World of Fashion

GIO_GRAPHY
Fun in the Wild World of Fashion

GIOVANNA BATTAGLIA

RIZZOLI
NEW YORK

New York · Paris · London · Milan

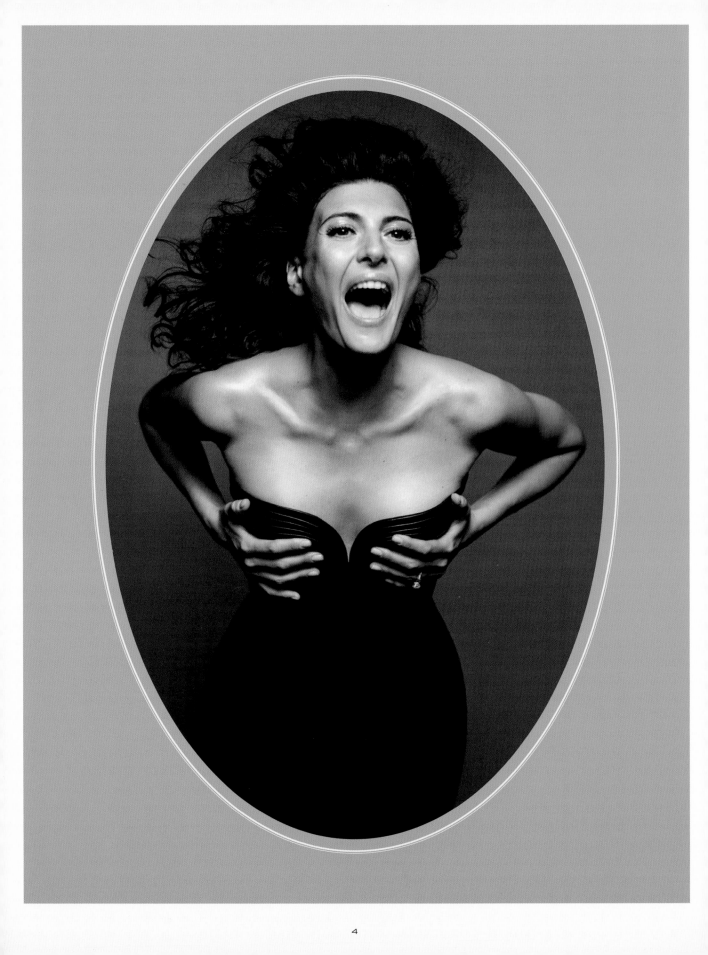

"BEING COOL IS A BORE; BEING FUN IS GLA<u>MORE</u>."

Giovanna Battaglia

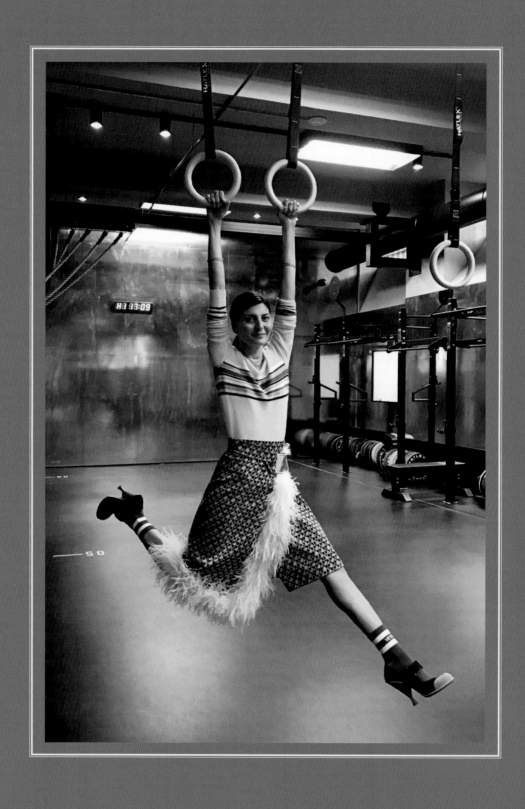

MY DRESSING
UP FRIEND

FOREWORD — NATALIE MASSENET

Consider this list: a bespoke floaty full-length chalky pink chiffon gown with a capelet by Giambattista Valli paired with a gold Grecian crown; a blue metallic bell-bottomed Abba "Dancing Queen" jumpsuit; a red Baywatch-inspired bathing suit with a personalized terry cloth headband, matching wristbands, and an American flag worn as a cape; a psychedelic Pebbles and Bam Bam furry mini dress and neon-pink afro; a beige suede fringed khaki safari skirt and matching blouse and desert boots; a white bathrobe, terry cloth turban, and white Converse; a vintage Oscar de la Renta black-and-white polka dot off-the-shoulder Dolce Vita tulle dress; metallic silver-fringed Giambattista Valli pants worn with Saint Laurent platforms with snake ankle straps and a sequined tunic; a faded flannel lumberjack shirt, a Gucci snake motif sweater, faded ripped jeans, and Prada platform hiking boots; a gold all-in-one sequined cat suit and floral headdress with built-in Christmas bobble decoration earrings; a chic vintage velvet Adolfo pleated skirt suit with a fitted jacket and Chanel bag; and a pink tutu. These are a handful of the outfits I have worn, in public, since becoming friends with Giovanna Battaglia.

About seven years ago I first saw Giovanna at a fashion show in Paris. I was attending the collections with my team at Net-a-Porter and she was working with *W* and *Vogue Japan*. It was hard not to notice her. Often surrounded by street-style photographers, Giovanna was always distinguishable as the chicest editor, in the coolest clothes seen off the runway. There she was coming out of the Ritz in black high-waisted leggings and knee-high silver studded Christian Louboutin riding boots—a fashion equestrian pairing, perhaps chosen to ride in style in the back of her stretch black chauffeured town car. Complementing this and every outfit was her striking aristocratic profile, a jet-black top-knot chignon, severe center part, and always, a bright friendly smile. I am not alone in worshipping the timeless style of the brunette brigade of fashion icons—

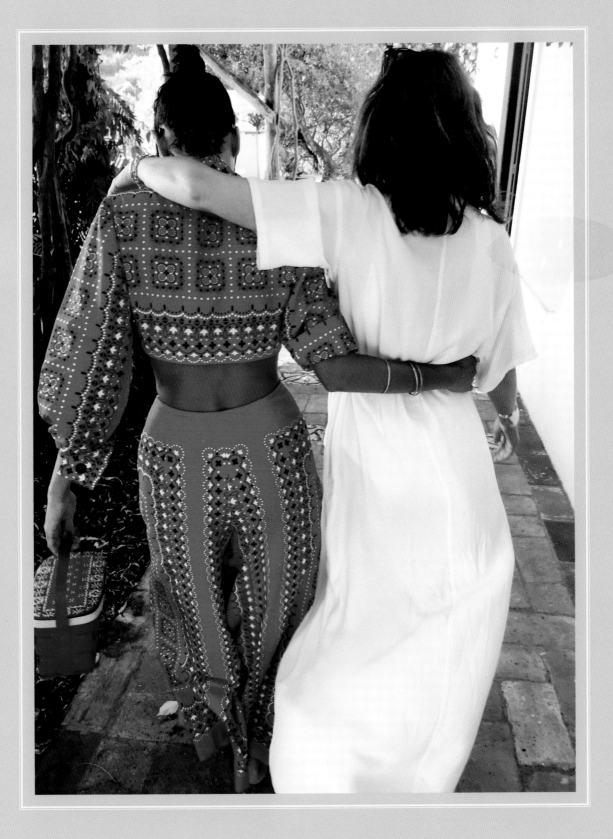

Jackie Kennedy, Audrey Hepburn, Maria Callas, Lee Radziwill, each of them a style hero of mine. And here in front of me was a new living, breathing version of this particular tribe. I had a style crush.

I remember when we first met. We were standing outside a Milanese warehouse, waiting for a Marni show to start. It was raining. Of course she had an umbrella (chic, white canvas, wooden handle) and I didn't. Without hesitating, she sheltered me and we stood under the canopy staying dry. With her warm, raspy laugh and Italian-twinged English she introduced herself without the typical pretense one can experience at a fashion event. It's great when someone who you admire for how they look turns out to be a pretty decent person. Giovanna Battaglia was not only envy-inducing and super-stylish, she was also nice.

Giovanna and I spent the next few years exchanging polite hellos, but we didn't get to really know each other, nor would I have worn the series of fantastical outfits I listed above if love had not intervened. Oscar, a brilliant Swedish friend of my equally brilliant Swedish boyfriend, fell in love with her and promptly married her. The next thing I knew, she was part of my life: weekends in the country, Sunday lunch at home, New Year's in St. Moritz, safaris in Kenya, sailing in the Virgin Islands. It was a whirlwind romance and a whirlwind friendship culminating in me joining her best friends as a bridesmaid in the most beautiful wedding imaginable in Capri.

So here is what happens to you when you spend some time with Giovanna. You start dressing up. I am not talking about fancy, expensive fashion just for the sake of it. But clothes to suit the mood, the location, and the theme. Thematic dressing is a big deal for Giovanna. She is an artist and fashion is the paint she applies to the life she is creating for herself and those around her. And as it turns out, this way of dressing makes life so much fun. There is something about hanging out with her that reminds me of being eight and dressing up in my mom's designer clothes, becoming, for a moment, the glamorous future self I imagined I would one day become.

It's likely that you will go through a similar discovery when reading this book. From the outside, you see @bat_gio, the street-star fashion icon who graces the pages of magazines. You see a woman who loves clothes, who dresses to be photographed, who is a modern fashion muse. But when you read this book you will get to know her; you will be struck and inspired by her humor, kindness, and genuinely warm outlook on life and people.

You will discover that you can make each day better through clothes. You will learn to approach each event, party, vacation, and Sunday walk in the park as a scene in a movie where you play the starring role.

I learned from my beautiful friend that clothes are not made to impress other people, but to make you feel great, to bring joy into every day. Each outing with Giovanna takes on epic proportions through our choice of clothes. Each event is made memorable not just for what we did, but for what we wore, like our all-day pool party; a private visit to Buckingham Palace; a Sunday lunch in the mountains; an all-night dance party in the middle of the Mediterranean; dinner with the girls at the local Mexican dive in Los Angeles; afternoon tea; a flight to Las Vegas; a sunset wedding ceremony; drinks in an Italian *piazzetta* listening to opera; sunset sailing to a deserted island in the middle of the Caribbean; a sunrise ride in a jeep chasing zebras; and a girls' night out in a club. I will leave it up to you to guess which of the outfits I listed above was worn to which event.

This is not a book about a girl who likes to wear fancy clothes in fancy places. OK, yes, of course it's a book about a girl who likes to wear fancy clothes in fancy places. But by reading this book with its funny, clever, and charming collection of lessons on living a stylish life, you will get to know Giovanna like I have and see the world through her eyes. And you, too, will understand the power, magic, and joy of dressing up.

London, April 3, 2017

NAT-GIO

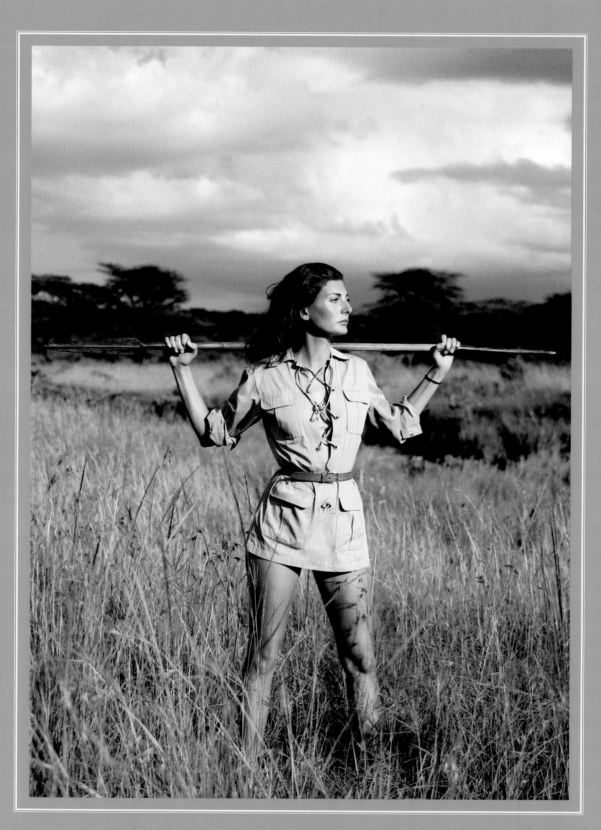

Vintage YSL, 1968

INTRODUCTION

GIOVANNA BATTAGLIA

From as early as I can remember, I've had an innate understanding of the power of visual storytelling. It started with Barbie. When I was growing up in Milan, I liked to organize fashion shows for my dolls. I would sew clothes for them. I had a Barbie house whose second floor I used as the "backstage" for the runway spectacle.

I soon graduated to humans. More specifically, to my younger sister, Sara, who was my first model and actress. (She continues to be my favorite muse to this day—even though she is a grown woman with her own clothing line.) I would make paper clothes—voluminous, colorful dresses and skirts that I designed—and wigs (one had a pair of braids, another a bouffant 'do), and then I would dress Sara up, enlisting my younger brother Luigi to play a rotating array of supporting roles. Occasionally, my older brother Antonio would play the strict, serious, snob roles—those were the roles I always gave to him. Then, using our VHS camera, I would film "shows" for our pretend TV channel called *Tela Ciospa* ("Ugly Girl TV"). Once I directed a parody of a famous 1990s Italian dating show in which Sara and Luigi began by having tea and chatting amicably only to devolve into fighting on the floor as I yelled, "Stronger! Stronger!" from behind the camera. Another time, I made a rendition of *Jurassic Park* in which Sara was a sexy scientist (in hot pants, no less) using a huge makeup compact to apply "excavation dirt" to her face while poor Luigi played a preening dinosaur in a brown costume. During the summers, when we would go sailing on my family's boat, I would choreograph and direct musical shows that Sara and I would perform for my family, not unlike the musical videos I now make on my phone.

I have always been the comedian and peacekeeper in my family. Diffusing tension by making a joke or cheering people up came naturally to me, and I think it speaks to my worldview today, too. It may sound simple, but I like making people smile. I prefer not to dwell on angry or sad or depressing things—not because I don't feel them, but because I'm always trying to find a source of light and happiness in this world. I could be doing something completely mundane, like standing in line for airport security. And instead of stressing out or getting annoyed at how slowly things are moving, I will start observing the people around me and make up stories about who they might be and what they might be feeling.

This vivid imagination led me to the fashion world; my gateway was *Vogue Italia*—a magazine of pure beauty from Franca Sozzani, its longtime editor-in-chief. The cover of the first issue I ever bought for myself—February 1996—featured Stella Tennant. I wanted to be her. And then, with each month's new issue, I wanted to be whichever woman had been brought to life within those pages. Working on this book after Franca's death was incredibly sad for me. Her vision is the reason I am where I am today.

Since starting my career in the fashion industry almost two decades ago, I have worked extremely hard. But my goal was always never to show it. I love the glamour in life—I don't want to see the darkness and grit that goes into it, but rather the beautiful result. It doesn't mean the tougher parts don't exist—of course they do—but I prefer to focus on the bright side. So that is what I choose to share. And sharing is very important to me. I'm not a singer or an important public figure or an actress. But I am someone who, through hard work and luck, has a life that affords me access to so many beautiful places, people, nature, and art. And when I see something beautiful, I want to spread that image to others in the hopes that they, too, can get some pleasure out of it. That is what this book is about.

When I first moved to New York City to start my career in America and began working for Stefano Tonchi at *W*, my friend Armand Limnander, the deputy editor, came up with the idea of "Gio's Journal": a monthly page in the magazine featuring my lighthearted take on my travels, nights out, and fashion. "Just send me pictures from your phone every month that are funny," he told me. "People are not going to be interested in that!" I said. "No, they're super fun," he reassured me. That was the seed from which the idea of this book eventually grew.

Oscar Wilde once said, "You can never be overdressed or overeducated." Dressing up for me isn't something that is a chore or an obligation. It is a physical manifestation of the fantasy side of one's mind. In decorating yourself, you please yourself first, then others. And by choosing what to put on, you are both a reflection of your inner state—or rather, the inner state you wish to project—and of the times that surround you. A great look can be a mood lifter. Not long after I settled in New York, I went to a party and I wanted to be a bit more dressed up. Someone said to me, "You are in New York now—not in Italy anymore." And I said, "I didn't come to New York to be a New Yorker—I came here to be an Italian living in New York with everything that comes with it, including all eighteen suitcases of clothes!"

I have always believed that personal style isn't just about the clothes you put on—it exists in everything you do, in the way you walk through life, in the way you choose to live. I choose to find the humor and light and fun in life. It is my antidote to the darkness that exists in our world. And you can find that beauty anywhere: in a gorgeous Icelandic landscape, in an exquisitely crafted dress, and in a head of lettuce from your fridge that somehow seems like a perfect chapeau. I hope this book brings you joy and inspires you to seek brightness wherever your eye lands.

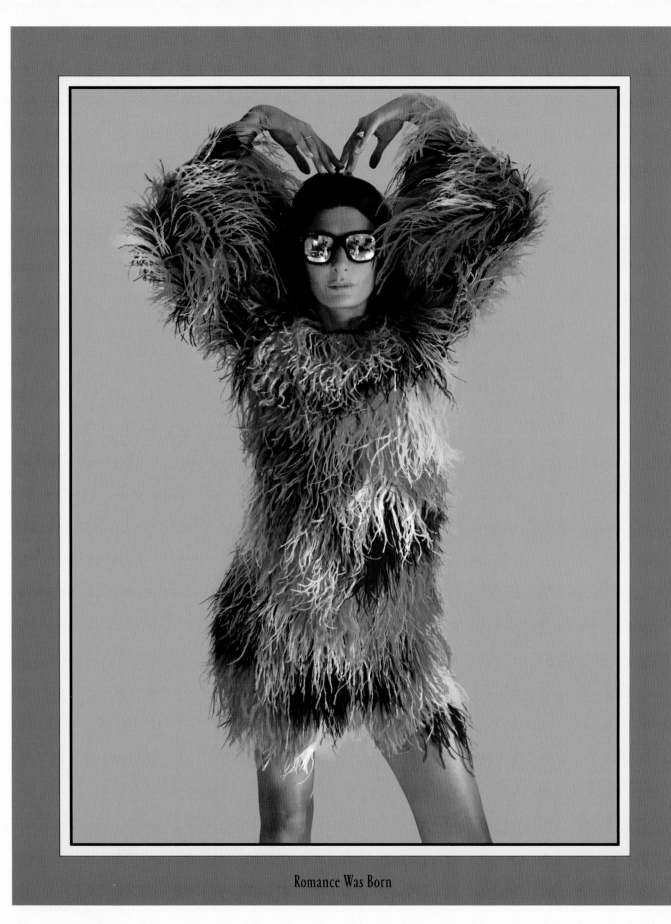

Romance Was Born

1

DRESS UP

1.
MY FAVORITE
COLOR IS...

DRESS UP

I have a more expansive
version of the color wheel.

It's larger than the average
person's and changes like a
weather barometer.

As such, my favorite colors
often aren't actual colors....

But they should be!

GIOTONE®
My Favorite Color

MY FAVORITE COLOR IS...
PRINT

DRESS UP

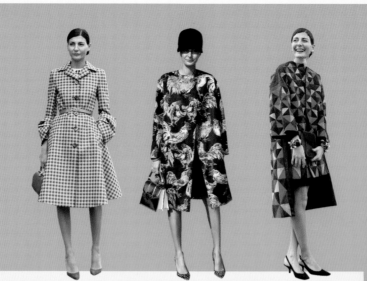

Prada Rochas Valentino

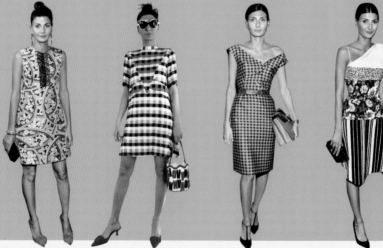

Giambattista Valli Tanya Taylor Prada Dior

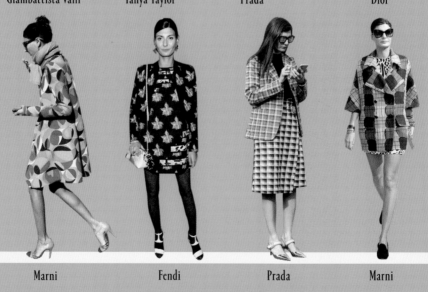

Marni Fendi Prada Marni

STRIPE

DRESS UP

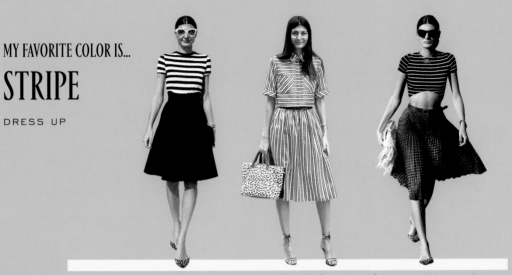

Acne skirt Tanya Taylor Marco de Vincenzo & Opening Ceremony

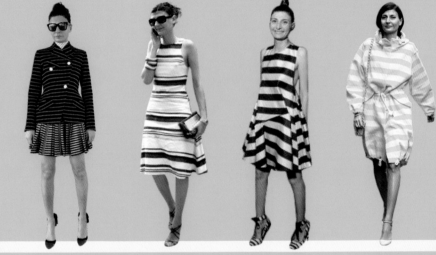

Proenza Schouler & Isabella Tonchi Boule de Neige Dior Max Mara

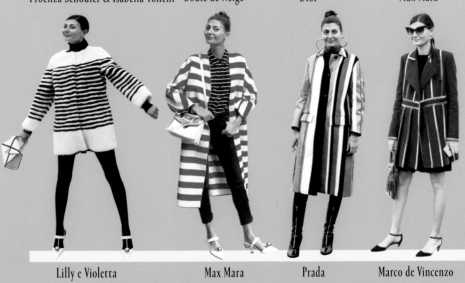

Lilly e Violetta Max Mara Prada Marco de Vincenzo

MY FAVORITE COLOR IS...
ANIMALIA

DRESS UP

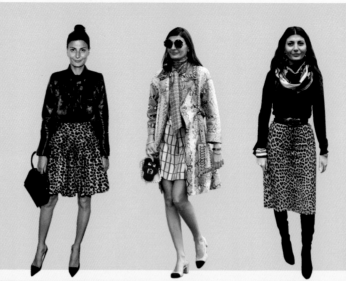

Alaïa Fendi Fendi skirt

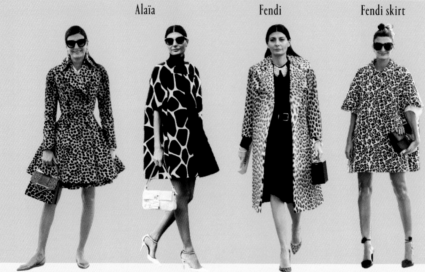

Alaïa Valentino Vintage Dior Sibling London

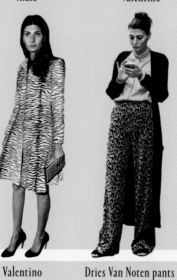

Valentino Dries Van Noten pants Alaïa DVF

MY FAVORITE COLOR IS...
BLACK & WHITE

DRESS UP

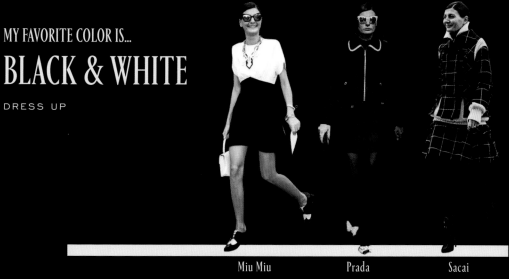

Miu Miu Prada Sacai

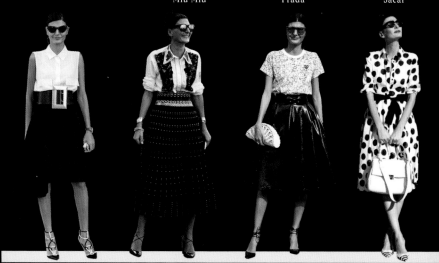

Equipment, Celine, Prada Miu Miu & Alexander McQueen Commes des Garçons Carolina Herrera

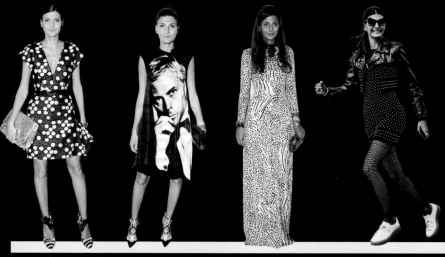

Giambattista Valli Giorgio Armani Issa Alaïa & Vintage Jean-Paul Gaultier

MY FAVORITE COLOR IS...
FLORAL

DRESS UP

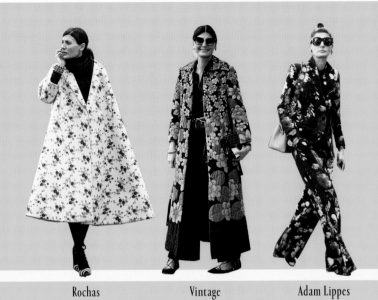

Rochas Vintage Adam Lippes

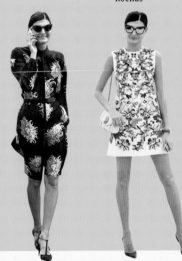

Carolina Herrera Valentino Giambattista Valli Vintage

Dolce & Gabbana Sara Battaglia Vintage YSL Erdem

MY FAVORITE COLOR IS...
SPARKLE & SHINE

DRESS UP

Tome Fendi Prada

Alice & Olivia skirt Chanel Altuzarra skirt N21

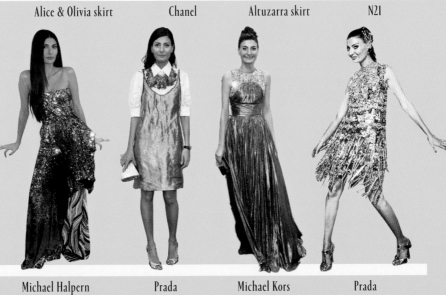

Michael Halpern Prada Michael Kors Prada

MY FAVORITE COLOR IS...
RAINBOW

DRESS UP

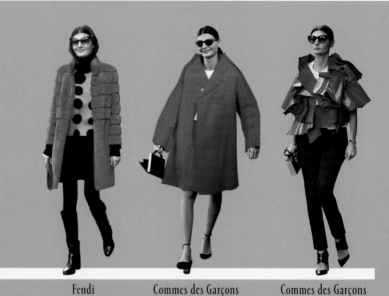

Fendi · Commes des Garçons · Commes des Garçons

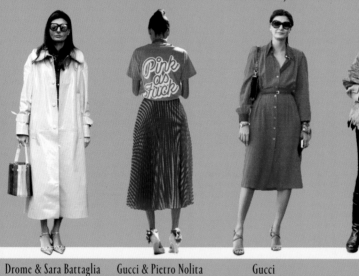

Drome & Sara Battaglia · Gucci & Pietro Nolita · Gucci · Vintage

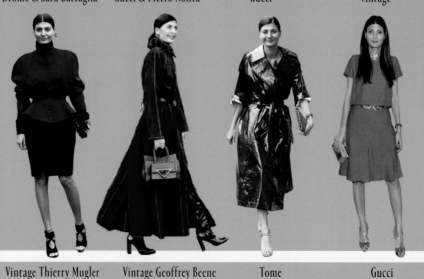

Vintage Thierry Mugler · Vintage Geoffrey Beene · Tome · Gucci

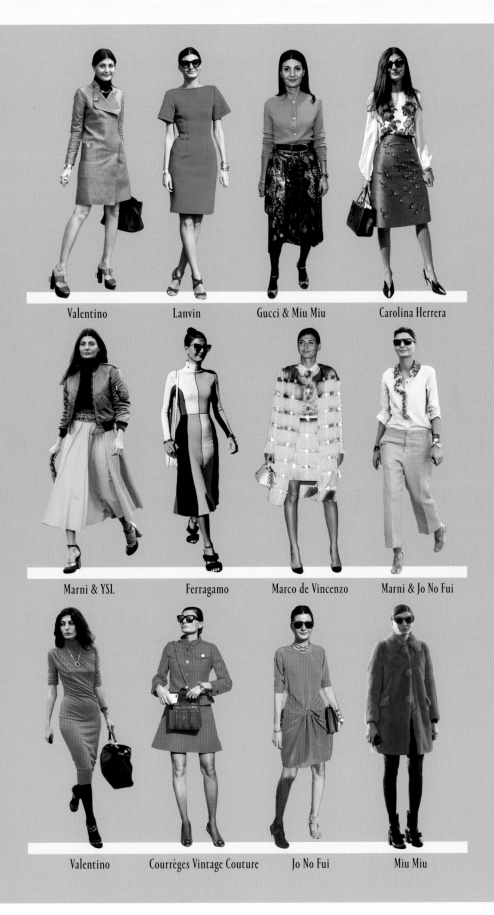

Valentino Lanvin Gucci & Miu Miu Carolina Herrera

Marni & YSL Ferragamo Marco de Vincenzo Marni & Jo No Fui

Valentino Courrèges Vintage Couture Jo No Fui Miu Miu

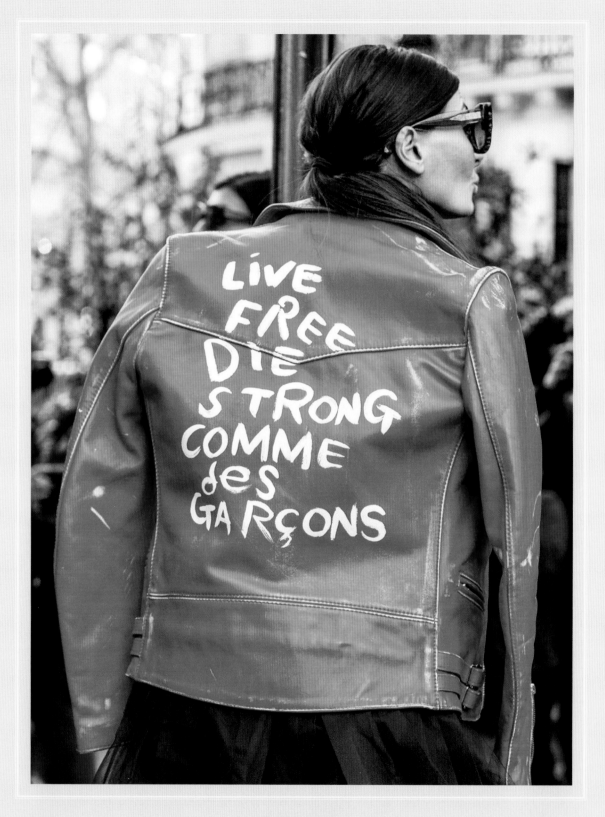

Commes des Garçons

2.
THE POWER
OF RED

DRESS UP

Red has so many connotations: it's a religious color, it's a happy color, it's a power color, it's a naughty color, it's even a warning color—think of stop signs. But no matter what your first association is, it is not a wallflower color. I didn't wear it much when I was younger. I think I somehow wasn't ready for it. Red has such a powerful and sophisticated impact that I almost needed to be more mature before I could own it. But now it's basically my version of black: it's a go-to. Every time Comme des Garçons puts red in a collection, I have to buy at least one piece! My breakthrough moment came about several years ago when I wore a red Givenchy ensemble to an event. I had actually owned it for a while and been too timid to wear it, but once I did, it was so great! It made me feel like a superhero. But even now that I am comfortable with this hue, I recognize that it is not something you can just throw on.

If you're wearing a red look, people's eyes will be drawn to you.

It keeps you on your toes, in that sense. You can't be sloppy or shy—you have to be put together to pull it off.

3.
RED RULES

DRESS UP

1. ## RED SIGNALS DANGER LIKE A SIREN.

So proceed with caution. It is a weapon that can work for or against you. Wear it with care.

2. ## DON'T MIX IT WITH OTHER COLORS.

Red has so much strength on its own, so you don't want to crowd it. If you're going to wear another shade, keep it to a neutral, black, or white hue so that your red piece pops.

3. ## KEEP ACCESSORIES TO A MINIMUM.

So the overall effect is graphic, bold, and simple.

4. ## WHETHER DOWN OR UP, HAIR SHOULD BE SLEEK.

The best makeup accompaniment is glowing, healthy skin, and well-defined features and a strong brow, but nothing over-the-top.

5. ## PERSONALLY, I PREFER NOT TO MIX RED LIPS AND A RED DRESS.

It's just too good.

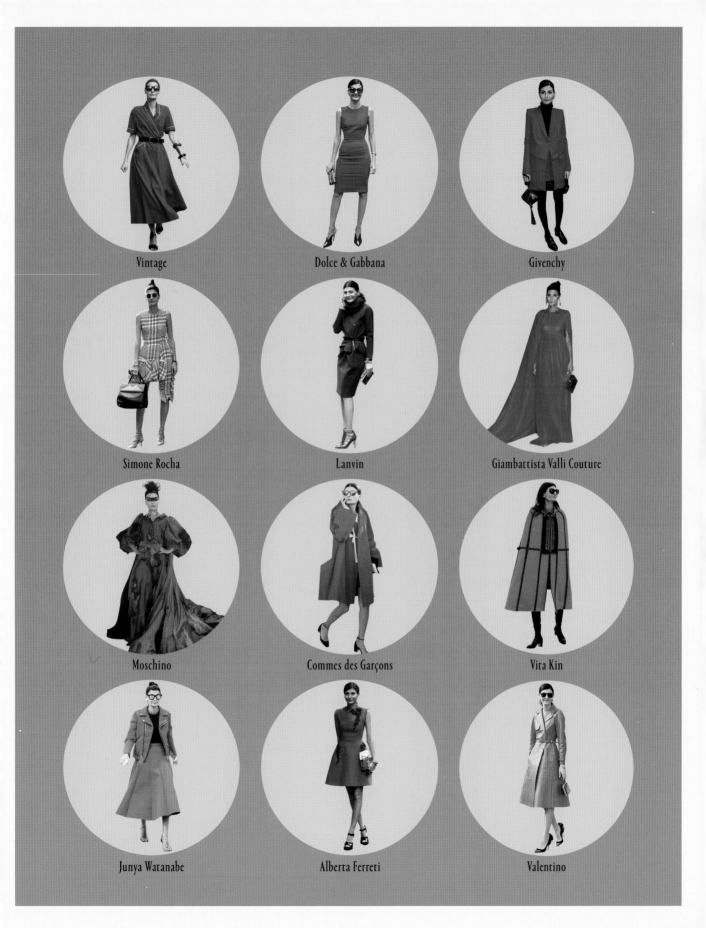

Vintage

Dolce & Gabbana

Givenchy

Simone Rocha

Lanvin

Giambattista Valli Couture

Moschino

Commes des Garçons

Vita Kin

Junya Watanabe

Alberta Ferreti

Valentino

4.
BAT GIO BEGINS

DRESS UP

It all started when I first moved to the States. No one could spell or pronounce "Giovanna Battaglia." I loved Batman as a kid because I've always liked to work at night, so I identified with his schedule. And he helped people anonymously—and, of course, how you could you not be enamored with his fantastic caped look?

And so I had a revelation: shorten "Battaglia" to "Bat" and "Giovanna" to "Gio."

Ecco! It made sense, too, because America is a country where anyone can become his or her own superhero if he or she works hard enough and wants it badly enough. That's the American Dream, of sorts. And having just moved to the States I figured I needed to prove myself, so why not have a superhero alter-ego moniker? Bat Gio is a version of me: a strong, self-possessed side of me. It works on social media, too. When I joined Instagram, I didn't want to be "Giovanna Battaglia" on that medium because it wasn't me, per se. It was a facet of me. So Bat Gio worked perfectly. It's who I show the world—and it doesn't hurt that capes are some of my favorite things to wear!

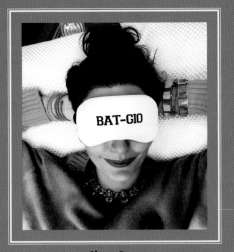

Sleep Bat

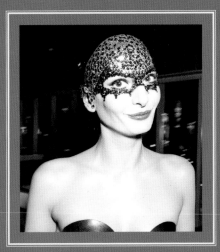

Crystal Bat

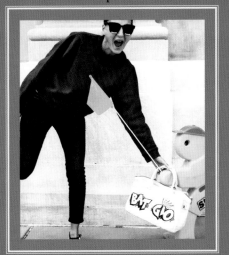

Bat Bag

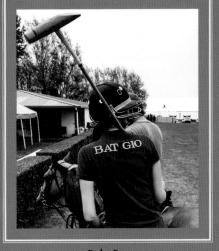

Polo Bat

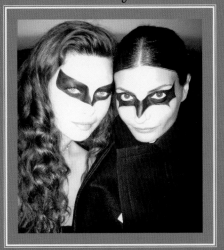

Bat Sisters

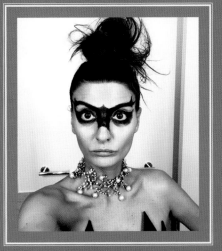

Bat Mask

5.
VINTA_
GIO

DRESS UP

Seeking out great vintage finds is like going on the ultimate treasure hunt.
And it's an addictive one—I'm constantly scouring 1stdibs. For me, it all began
when I was a teenager growing up in Italy. There was no "fast" fashion back
then, so if you wanted something cool to go dancing in, a vintage piece was
way more affordable and often more fun than something contemporary.
My passion just grew from there, and, as an adult, I've begun to feel more like
a collector. There's a craftsmanship to vintage that is different than what you
might find now. And it's an easy way to make sure you're the only one wearing
a particular dress to an event! The surprise factor is built in because people
are always trying to figure out where something is from.

I find it so amusing when an older piece ends up seeming modern and contemporary to people.

Professionally, I'm always so focused on future trends; there's something
really refreshing and unexpected about looking to the past instead of toward
the future when I'm getting dressed for myself.

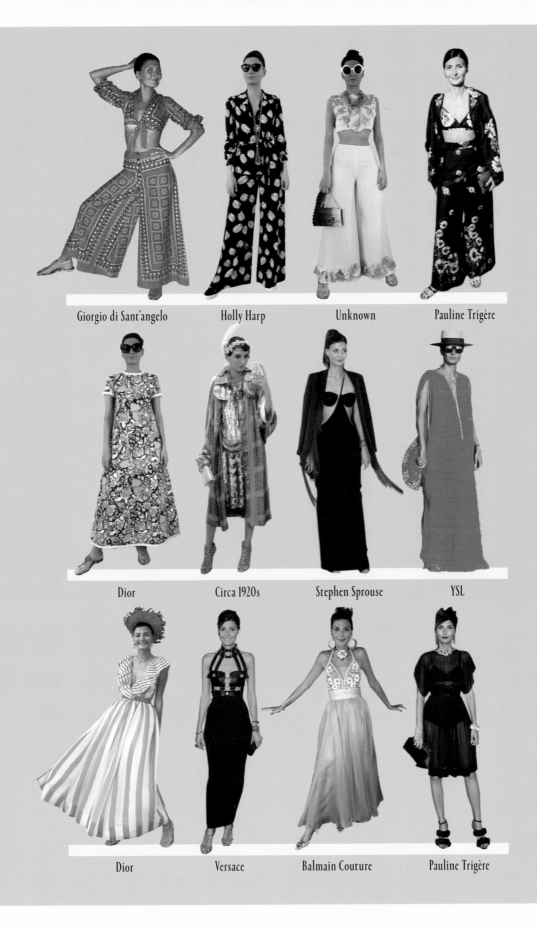

Giorgio di Sant'angelo Holly Harp Unknown Pauline Trigère

Dior Circa 1920s Stephen Sprouse YSL

Dior Versace Balmain Couture Pauline Trigère

6.
MORE IS
MORE

DRESS UP

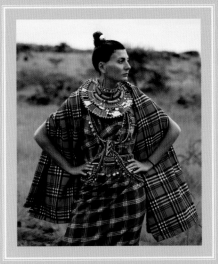

Kenya

Mexico

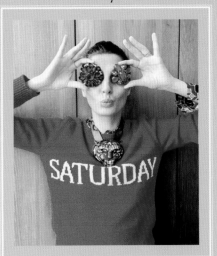

New York

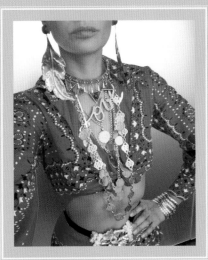

Fantasy Island

Historically, women have been drawn to extreme decoration. Look at the intricate headpieces worn by Cleopatra, a Tang Dynasty empress, or Marie Antoinette's accessories collection. I am not immune to such charms, albeit on a much smaller scale! Hence, my love of jewelry and moreover, layering and mixing pieces to create a multi-faceted look. When it comes to acquiring new jewelry, I am most attracted to one-of-a-kind, unique finds. So one of my favorite things to do when I'm in a new place is to seek out local jewelry of some kind. I've found body chains in Kenya and turquoise necklaces in Mexico City and amazing fringed earrings in Mykonos. For me, discovering and wearing these baubles is a way to bring different parts of the world into my closet.

7.
JEWELRY FRIENDS

DRESS UP

To me, jewelry has a soul, like the toys in *Toy Story*.

When I travel, I like to take my pieces with me as they are my fantasy destination companions!

I often animate them into faces and characters. They become like living, breathing creatures that keep me company while I'm away.

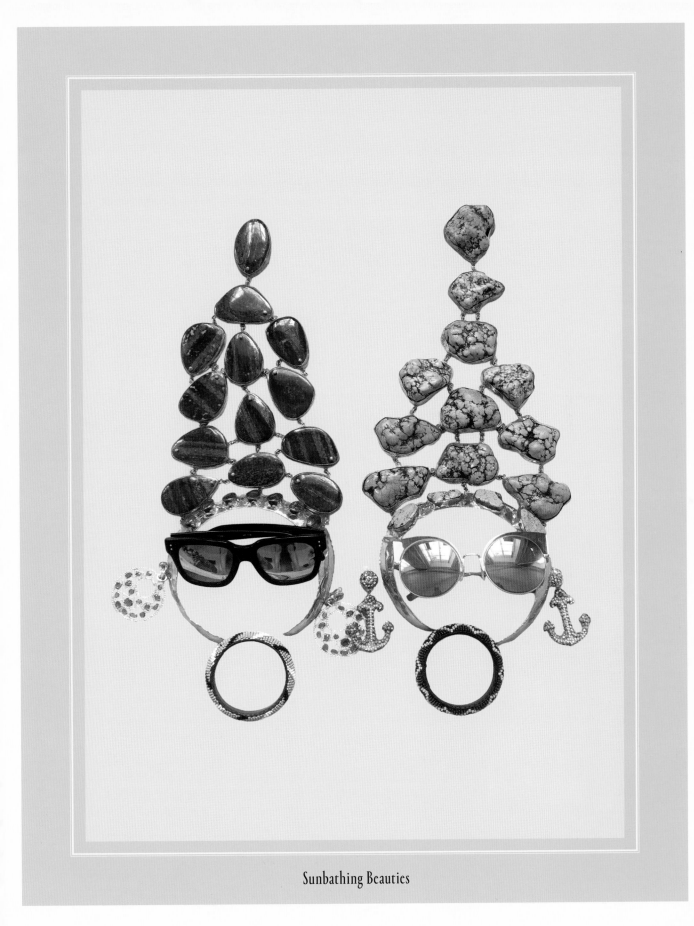

Sunbathing Beauties

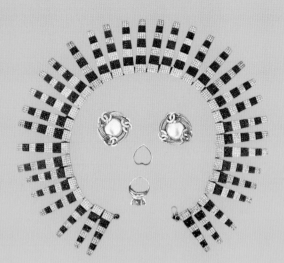

Pretty Porcupine

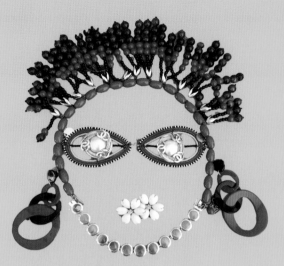

Caribbean Dream

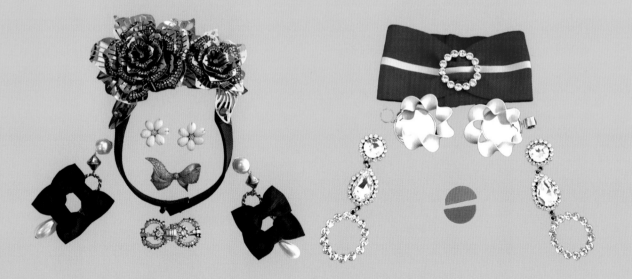

Rosetta

Sporty Spice

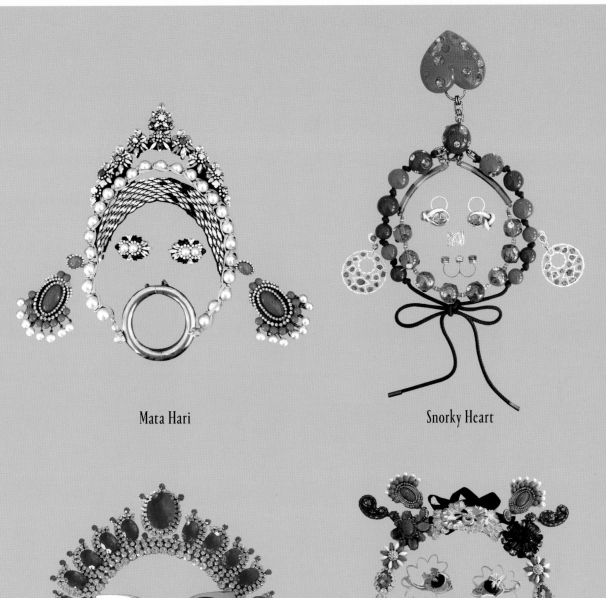

Mata Hari

Snorky Heart

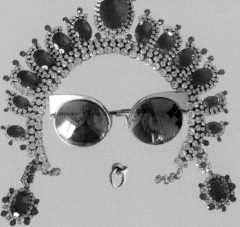

The Woman in Red

Bird of Paradise

8.
HAT
GIO

DRESS UP

Mariachi is always a good idea—
if the band doesn't show up in time.

If you forget your bathing suit—
try an oversized straw hat.

Sometimes the best accessories—
are just sitting around in the fridge.

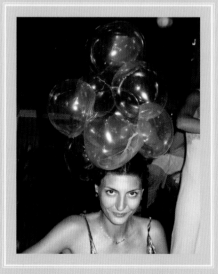

When you live in a bubble—
accessorize accordingly.

I never miss an opportunity to create a fun look when the moment presents itself. Putting on a hat is one of the quickest ways to do that. It's transformative, the dot on the 'i' that punctuates an ensemble. (Even better if you can get a friend like Bianca Brandolini to join you *a tanto di cappello*!) I've never limited myself to normal materials. I prefer to make a hat out of anything. Why not put a hat on?

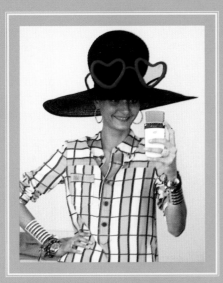

When you're feeling amorous—
wear your heart on your head!

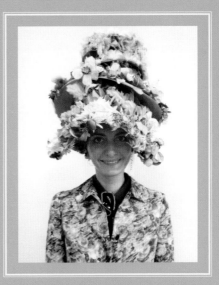

When you can't make up your mind—
try them all.

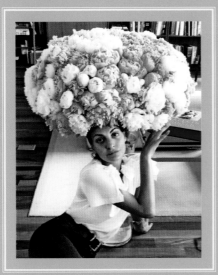

When you love flowers so much—
you can't bear to only have them in the vase.

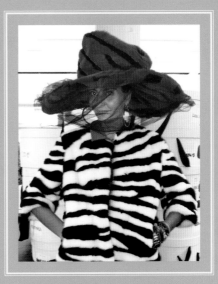

When you feel like a queen bee—
Marc Jacobs is the answer!

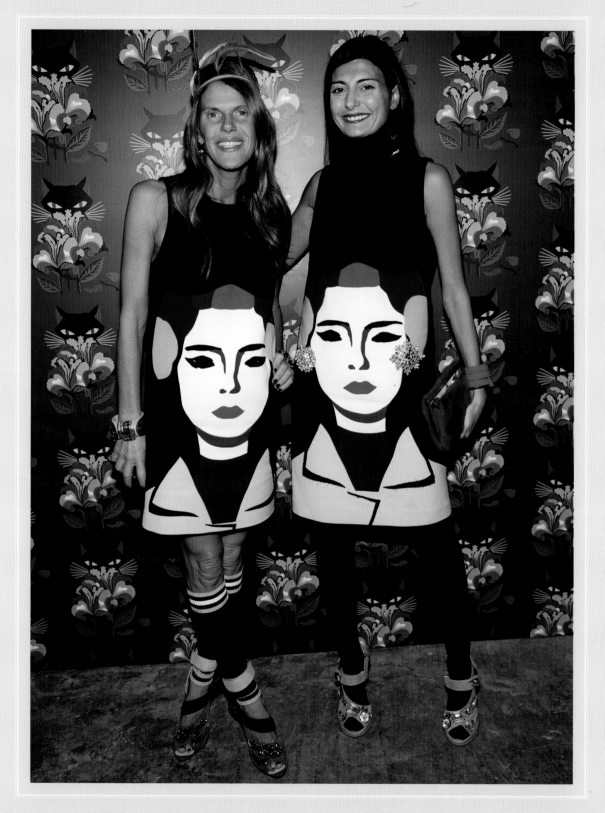

Prada face-off with Anna Dello Russo

9.
THE ART
OF TWINNING

No matter how individual your sense of style is, if you socialize enough, it's inevitable that at some point in your life, you will walk into a party and be confronted with another woman in an identical (or nearly) outfit. Wearing the same dress as someone else is generally considered the ultimate social faux pas. But I actually think it's funny and an opportunity for humor! Case in point: I was at a dinner at Art Basel Miami one year and chose to wear a long, black Calvin Klein slip dress. I walked into the restaurant and spotted my friend. Mollie Ruprecht Acquavella in the exact same dress. And to top things off, we had even styled our hair similarly. We laughed and decided to spend the whole night by each other's sides, like the dancing twinsie emoji. And we had so much fun! She became my party buddy. I was lucky that she and I knew each other, but if it's a stranger, it can still work out.

Think of your identical outfits as an icebreaker—maybe you'll make a new friend. You already know you have one thing in common: good taste.

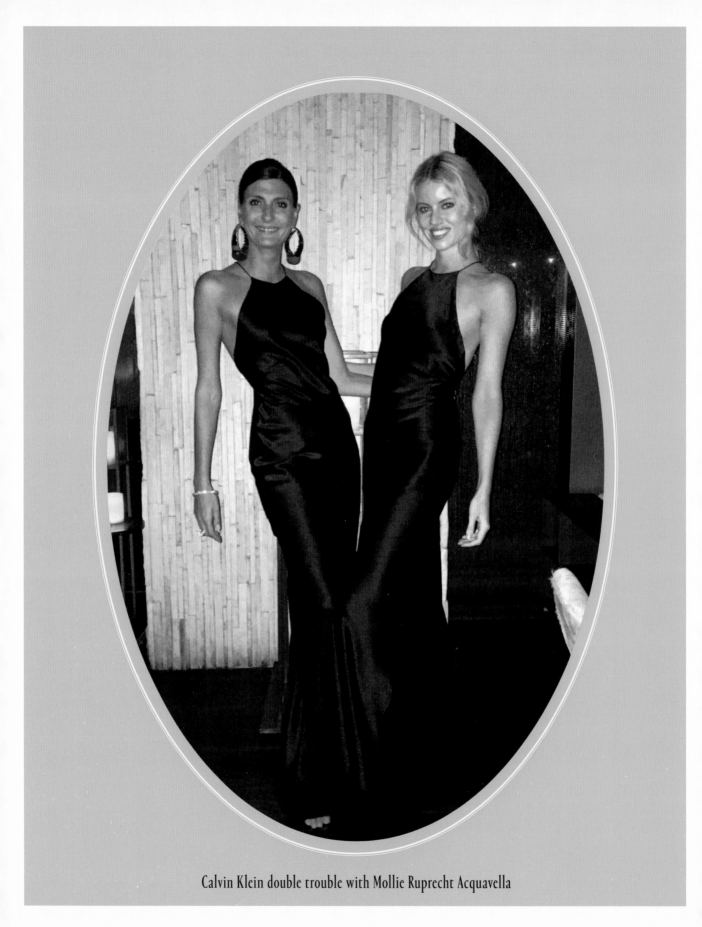

Calvin Klein double trouble with Mollie Ruprecht Acquavella

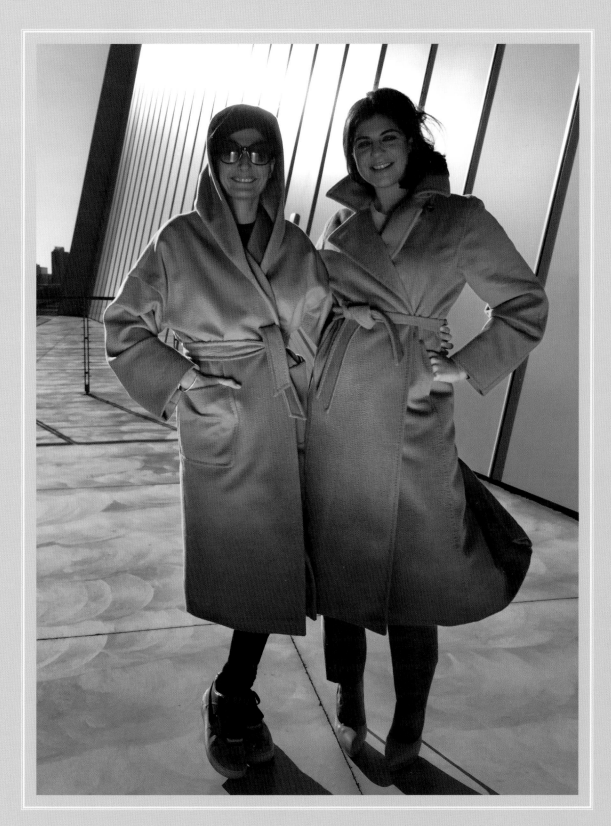

Camel Coat to the Max (Mara) with Maria Giulia Maramotti

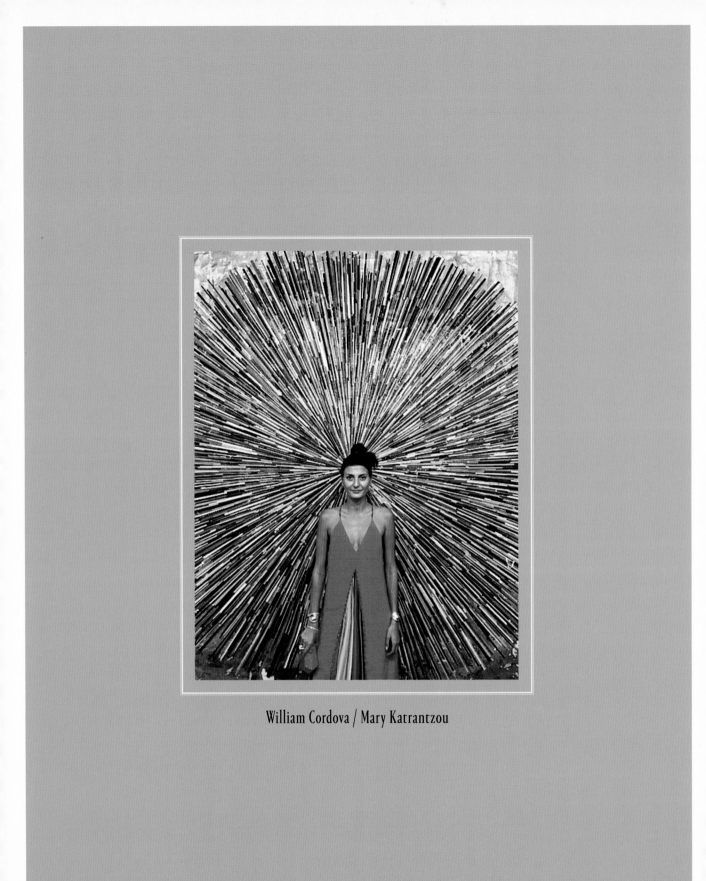

William Cordova / Mary Katrantzou

10.
WORK ART
PLAY ART

DRESS UP

When I was growing up, going to art fairs was considered boring. Hard to imagine, I know, given that they are now such major social hubs! My mother is a sculptor and a professor of sculpture at the Accademia di Belle Arti di Brera in Milan, and my brother Antonio owns a gallery in Milan. From a very early age I can recall going to fairs in Milan, Bologna, Turin, where I was surrounded by the eccentricity and big personalities of Italian artists. It was through these experiences that I became immersed in the works of people like Piero Manzoni, Alighiero Boetti, Lucio Fontana, Giorgio de Chirico, and Mimmo Rotella, among others. But at that time, fashion and art did not have the intertwined relationship they do now. So perhaps in a nod to that,

I've invented a certain game as an adult: every time I go to an art-related event, part of the fun in getting dressed up is hoping I will find a work of art that night that matches my outfit.

It's like my version of a party trick! And it further, however playfully, shows the ways in which fashion and art are in a constant dialogue.

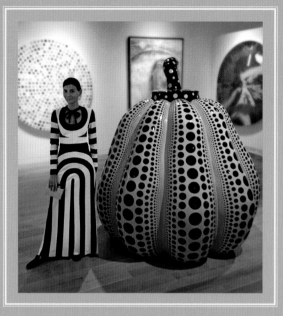

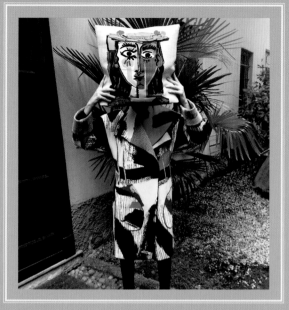

Yayoi Kusama / Marc Jacobs

I found the perfect transportation home—
a Yayoi Kusama pumpkin instead of an Uber.

Picasso / Celine

This Picasso pillow perfectly expressed
my inner face of that day.

Takashi Murakami / House of Holland

I found my art fair friend for the day and we
were both twinning in my favorite color rainbow.

Rob Pruitt / La Double J

A multicolored La Double J dress was the
way to go for Rob Pruitt's multi-faces.

Alighiero Boetti / KTZ jacket

If you can't buy an Alighiero Boetti, perhaps you
can wear one? This KTZ jacket was way more
affordable than one of his paintings.

Rudolf Stingel / Dolce & Gabbana

I felt completely at home in this Rudolf Stingel
installation—I was so comfortable, I wanted to have
a sleepover in my D&G pajamas! Totally normal.

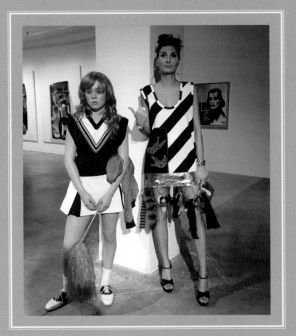

Duane Hanson / Miu Miu

I found myself a cheerleader to match my
Miu Miu with Duane Hanson.

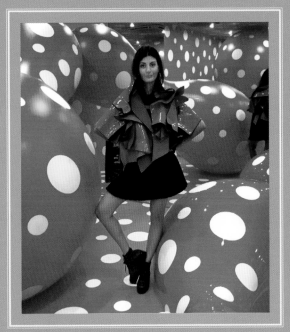

Yayoi Kusama / Comme des Garçons jacket

I love Yayoi Kusama so I'm always living
in a Kusama world and I am a Kusama girl.

11.
FIT TO
BE TIED

DRESS UP

Before

I wore this amazing long, red, caped Giambattista Valli couture gown to the premiere of my friend Francesco Carozzini's documentary, *Franca: Chaos and Creation*, at the Venice Film Festival. When we were headed to the after-party, I was worried I was going to ruin the dress, tearing its long train by traipsing around Venice and climbing in and out of water taxis (all with the potential for stabbing the cape with a sharp heel). Fortunately, the designer Peter Dundas was with me and he had a solution: he made all these creative knots that turned my gown into a ruched mini-dress and he picked up the

After

cape in the back and made a twist and knot with it, connecting it somehow to the bottom hem of the dress. It was like watching a magician! And Ecco! My gown went from premiere-worthy to party-ready in mere minutes. It was like a much more ingenious version of wedding gown bustling. And it taught me an important lesson: when going out in a major dress, if you aren't lucky enough to have two designers with you, the one who made the gown and another who can transform it for the after-party, always have a creative contingency plan of your own so you don't miss the after-party.

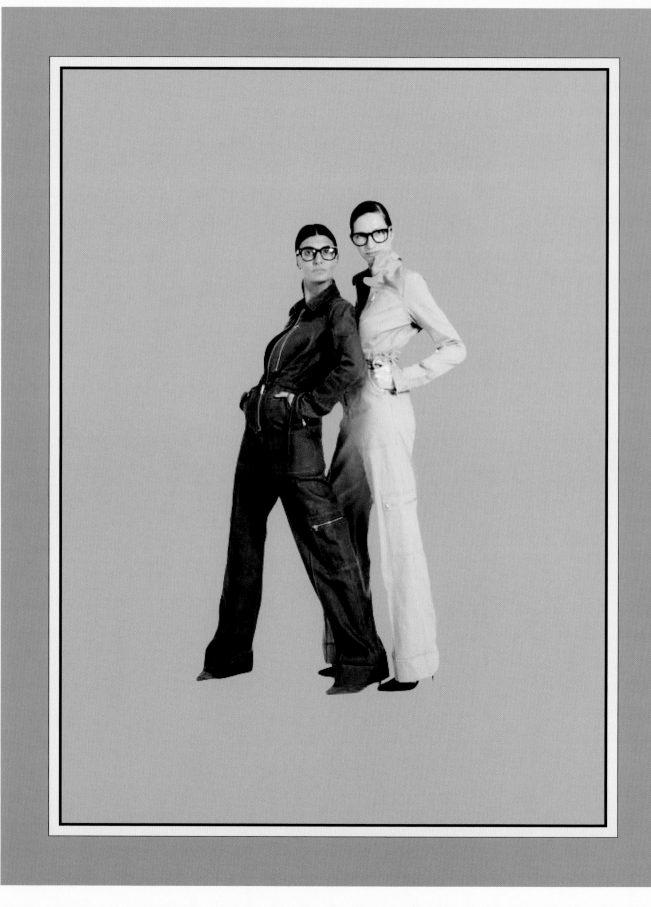

2

READY
FOR ANYTHING

12.
THE TALE OF THE
BROKEN DRESS

READY FOR ANYTHING

This picture was taken at the Met gala for *Schiaparelli and Prada: Impossible Conversations*. I decided to channel Frida Kahlo because of the Surrealist undertones of the exhibit, so I went with a black floral embroidered gown from Dolce & Gabbana Alta Moda with a mermaid-meets-hourglass silhouette, topped with fresh roses pinned as a crown on top of my head. Before dinner, I had the brilliant idea of going to the loo.

I unzipped the back of the dress, but when I stood and tried to zip it back up, my curvaceous Italian posterior proved too much for the dainty zipper,

and it broke off in my hand. There were no hooks and eyes, so I now had a gaping hole from my neck all the way down to my butt, like the open back of a hospital gown! Cate Blanchett and Stella McCartney happened to be in the bathroom at the same time as I was, but Blanchett took one look at my predicament and after cooing, "Oh, how awful!" exited the space, with McCartney in her wake, nonchalantly abandoning me in my time of need.

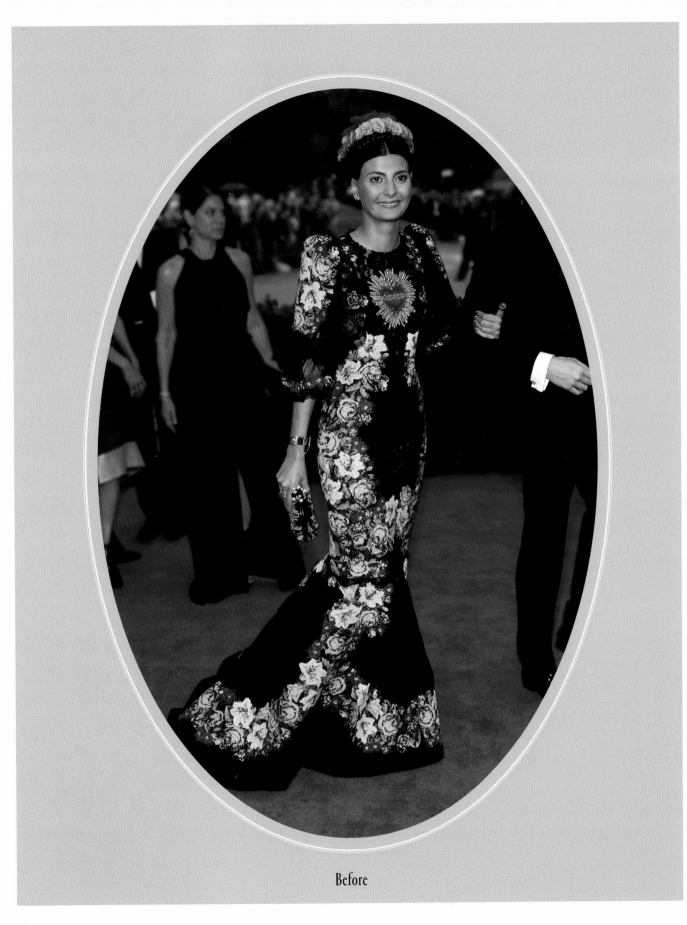

Before

A few lovely custodial women tried their best to help, but it wasn't until a blonde angel entered dressed in pink, as all of the *Vogue* escorts were, that I found salvation. She took one look at me and said, "I will fix this!" then rushed me through the empty galleries to the backstage area, where performers were getting ready. There, by happenstance, I saw a former assistant and after a quick exchange, she applied a package's worth of safety pins to suture the dress's back. (The blonde angel—Selby Drummond—has, fittingly, gone on to become the accessories editor for *Vogue*.) Thus closed, I headed into dinner. And as luck would have it, I was the very last person to arrive—pretty much the biggest taboo a person can commit in Anna Wintour's eyes—and my table, hosted by the Courtin-Clarins sisters, was in the center of the room, so I had to scooch past everyone to get there. "Here comes the late Italian, again," I imagined everyone thinking.

Fortunately, my new Frankenstein look proved very popular. "Fah-bulous," remarked a friend of my dress. "It's genius!" proclaimed Alber Elbaz,

thinking the safety pins were an intentional touch, specifically referencing Surrealism. Only at a fashion gala could such a disaster become a triumph! Needless to say, I did not go to the loo again for the rest of the night.

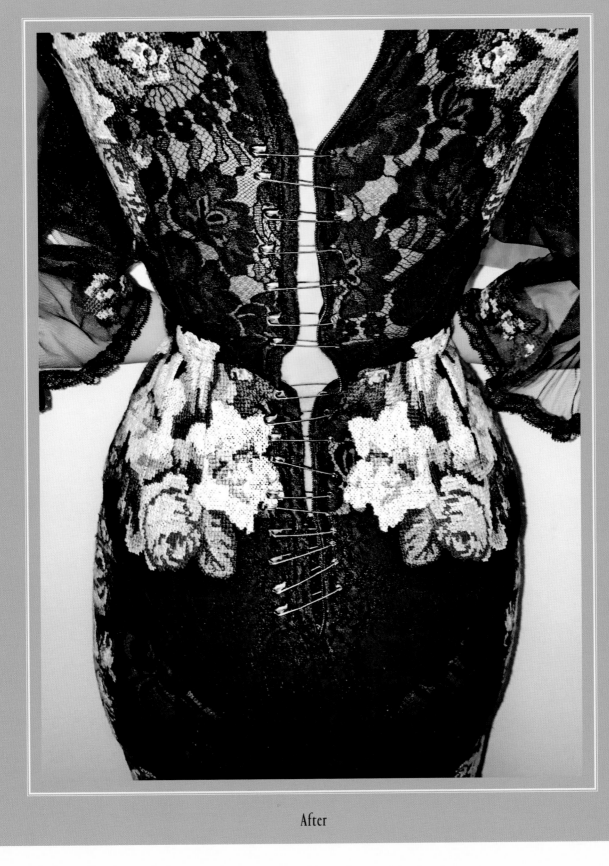

After

13.
HOW TO WEAR THE SAME OUTFIT AGAIN

READY FOR ANYTHING

Paris

Let's be honest, you're not committing a crime by wearing the same look more than once. Remember: even the Queen of England repeats outfits. But there are ways to repeat a favorite dress or piece properly: always have a new set of accessories, and choose occasions that are different in nature and have a different crowd so people won't remember having seen it. You would be surprised how fresh almost anything looks with some new styling. Some dresses are like wine: the more they age, the better they get. Often the second or third or fourth time you wear something, you are able to make a more

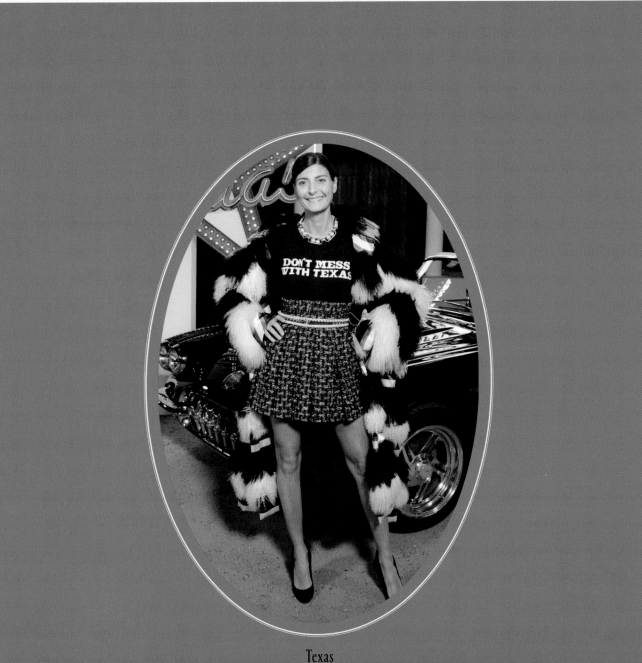

Texas

interesting look because you don't treat it in as precious a manner. This silk
and shearling vintage Balmain coat is one example. I found it at Forty Five Ten
when I was in Dallas for the Chanel Métiers d'Art show. It was unseasonably
cold outside, so I could wear it to the Chanel show with a Chanel skirt and a
T-shirt. Six months later I wore it during Paris Fashion Week with flat shoes
and tights, treating it like a dress. It's almost like the coat was my face and
simply by tweaking things a tiny bit—the fashion version of changing up my
makeup—my overall look was transformed.

14.
HOW TO QUICK CHANGE...
THE STORY OF MY LIFE

READY FOR ANYTHING

If you're not Anna Dello Russo, who can change her outfit in a moving car (see page 192), figuring out how (and where) to make a quick change between events can be tricky. But when you have to go from one thing to another to another, and they all have different vibes and dress codes, you can't wear the same outfit to each one. Even before I had a jam-packed work-related schedule to contend with, I used to bring more than one outfit to a club with me and switch it up halfway through the night. It was a way to change the mood and sometimes I just couldn't decide between two or three things—so I figured, why not wear them all? If you love fashion, this is one way to maximize your wardrobe! Over the years, I've changed in parking lots, in the bathrooms of bars, in the toilets of airports. The pinnacle of when I deal with this situation is during fashion month, particularly in Paris, where the events are super spread out and I never have enough time between, say, a runway show and a cocktail party to go back to the hotel and exchange looks properly.

So I've developed a system: I walk into random hotels, channeling the vibe of an international spy.

I use my instincts to go right to the main lobby bathroom wearing one thing and emerge wearing another, all while my driver waits outside. By now, I have my favorite spots all over Paris that I like to use. They're my secrets, but I will tell you, the key is to change in a hotel that is not super well-known so you minimize your chances of running into anyone you know. One particular occasion comes to mind: I was wearing a sequin Valentino dress and coming from a fashion show and had very little time before I had to be at Natalia Vodianova's Naked Heart Ball at the Fondation Louis Vuitton. The sparkly Valentino, despite seeming evening appropriate, was really perfect for day.

Before: Valentino Dress After: Givenchy Suit

Also, given the LVMH event was for work, I wanted something more straight-forward. So I had a white Givenchy tuxedo suit in a shopping bag waiting in the car for me and I popped into a hotel carrying it and left wearing the Givenchy, the Valentino neatly packed up. Voilà! There are some important tips to keep in mind: your hair and makeup should be simple so that it can work with both looks and not require any touching up, and it's best to choose something you can zip up on your own so you're not stuck in a hotel loo for twenty minutes by yourself with an open dress, waiting for someone to walk in and help you! Other than that, anyone can have their own "Superman in a phone booth" moment.

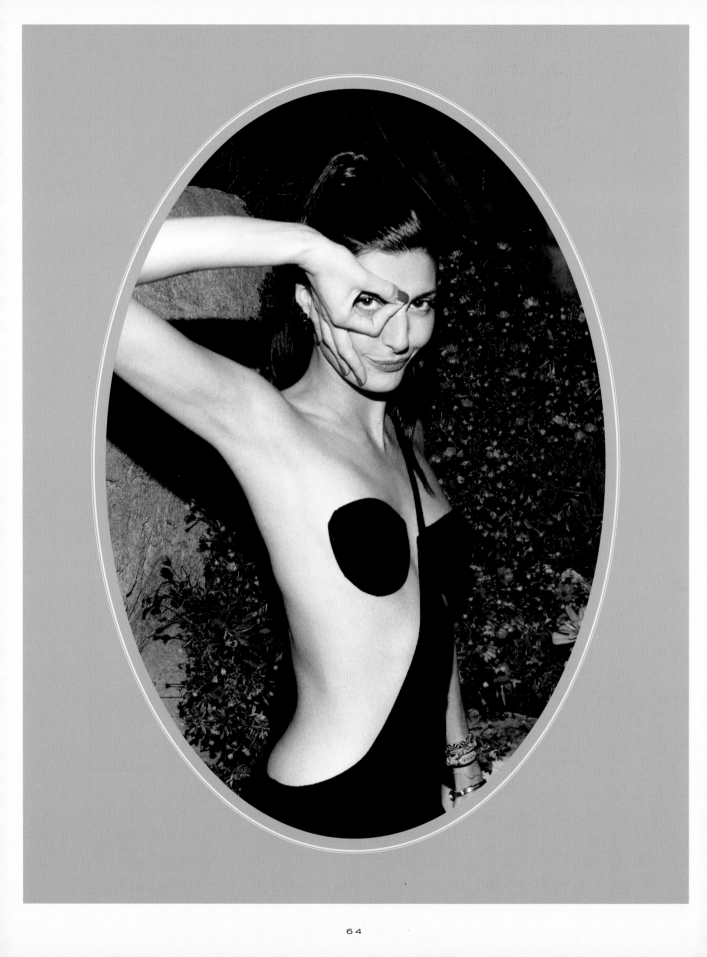

15.
FASHION EMERGENCIES

READY FOR ANYTHING

Stephen Sprouse was a pioneering American designer in the 1980s, heavily influenced by pop art, grunge, and 1960s art. I bought this unreal Sprouse dress at the New York vintage mecca Rare Vintage to wear to an amfAR dinner at the Cannes film festival. This particular piece featured an asymmetrical halter strap with a cutout torso and two separate bra cups. On the body, it's supposed to float, almost defying gravity. Because of its crazy construction, when I tried it on for friends, everyone kept saying,

"Oh my God, they're going to fall out!" assuming I was going to end up with a Janet Jackson moment—

only worse!—when my top inevitably came down. But I was like, "Guys, there's no way it's going to fall." Like any fashion lover, I was absolutely determined to wear my discovery and made sure I had every tool necessary to accomplish this. And so my assistant at the time got me the best adhesive tape ever, Topstick. It was so strong that I felt as if I was waxing my chest when I took off the bra cups at the end of night!

16.
LAST-MINUTE GETTING-READY
SURVIVAL GUIDE

READY FOR ANYTHING

01 Make sure you know what you're wearing in advance, and that it's stain and wrinkle free. If you want to wear a dress from ten years ago, be sure you're the same size and that the zipper isn't broken from a previous party. If it's new, make sure you take off the tags. I was once at a cocktail party in a Balenciaga dress and someone was like, "I love this Balenciaga!" and I was like, "How did you know it was Balenciaga?" And they were like, "The tag is hanging out and by the way, you paid too much for it!" Mortifying!

02 When you are pressed for time, don't take this as an opportunity to try out some fancy eyeliner trick. Keep things simple and familiar. I've been guilty of this and of course, it was with the most persistent, waterproof eyeliner on the planet and I ended up with a panda-eye look.

03 No matter what, you have to take a shower, even if it's only for a minute and a half. Trust me, it's possible. Set your iPhone alarm for ninety seconds and go! You'll be impressed at how much you can accomplish. But whatever you do, don't shave anything. It's just mathematically a given that if you're shaving so quickly, you will cut something. Trust me: as an Italian woman, I have an eternal fight against body hair and it's a battle that takes no prisoners.

04 When you get out of the shower, you'll want to moisturize. Let your body cream dry first! Otherwise, you will end up like I once did, wearing a chiffon dress that appeared to have a new camouflage print.

05 Don't try to do too many things at once or you might just find yourself with Lancôme waterproof mascara on your teeth and Crest whitening toothpaste on your eyelashes, not that that's ever happened to me . . .

06 Don't even think about squeezing any blemishes before you go out unless you want your face to look like a crime scene.

07 If your dress happens to be arriving via a box from a foreign city, make sure you have something to open it with so you don't end up calling down to reception and screaming, "Bring a knife, bring a knife, now!" (Yes, this has happened to me with a beautiful Alexander McQueen dress and I probably sounded like a homicidal maniac when the front desk picked up.)

08 Always try your shoes on beforehand. It's best to wear them while doing your makeup before putting on the dress. But be careful when putting on the dress that the heel doesn't get stuck in the hem and rip the dress.

09 If you only have a few minutes, make sure you have transportation waiting for you because it's a matter of fact that something bad will happen for sure when you're in a rush and you haven't planned this out: your Uber will suddenly have a thirty-minute wait or be stuck in traffic. The fates do not look kindly on last-minute endeavors!

10 Figure out your bag situation in advance, and do not be seduced by purses that are too small to fit your essentials. No matter how hard you try to squeeze your phone, keys, and gum into a micro clutch, hoping it will expand, it's just not going to happen.

11 And finally, do not make a mistake with your underwear choice when wearing a sheer dress. A dress can appear perfectly opaque in your apartment, and suddenly in the light of your elevator, it becomes an X-rated movie. To avoid discovering this after you've left your apartment, try taking a selfie with a bright flash while facing the mirror.

17.
WHAT TO DO WHEN YOUR
SHOES START TO HURT

READY FOR ANYTHING

01 Don't be afraid to take them off (even if they are beautiful Dolce & Gabbana Alta Moda shoes). Better to be in a good mood. Pain is not pretty.

02 Take your cue from Get Smart and use them as modified telephones. Who knows, they might actually work? At the very least, it will help create a conversation.

03 If you happen to be next to a famous international director, use them as a way to introduce yourself. (See picture at right.)

04 But remember, if you do take them off, you need to still walk as though you are actually wearing high heels. Act like a ballerina and stride delicately on your toes.

05 Or best of all, before going out, follow the advice of Linda Fargo (page 208)!

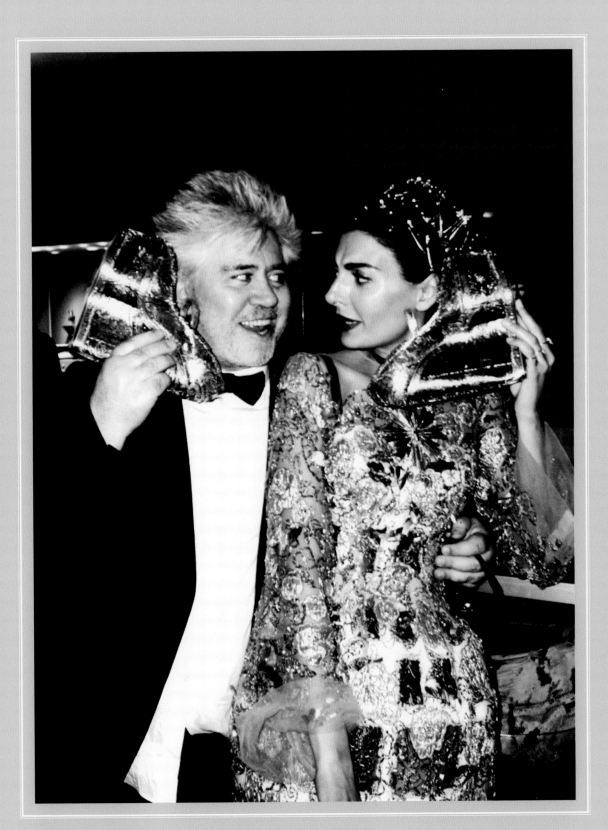

Pronto! Pedro Almodovar!

18.
LAST MINUTE BEST-DRESSED LIST

Sometimes the best fashion moments are born of spontaneity. Take how I ended up with a coveted spot on *Vanity Fair's* annual Best Dressed List: I was having a really long day of prepping an upcoming photo shoot. Suddenly, at five p.m., I realized I had a black-tie gala I had to attend and, believe it or not, I had not thought about my outfit yet! I began mentally going through my closet, and stopped on a Carolina Herrera skirt from her most recent collection, which I knew would be perfect because the event in question was a glamorous, old New York–style ballet gala. *Perfetto!* Now I just had to figure out what to pair with it. Even on such a tight time frame, I wanted to have a proper, dramatic fashion moment. I ran to my drawer of tops and dug through it, looking for a short, slightly edgy piece that would offset the high-wattage glamour of the voluminous ball-gown skirt. The obvious choice—at least for me—was a leather Alexander Wang tank that I had last worn to a rave in Ibiza. I still needed something shiny, so I made a beeline for an Oscar de la Renta costume jewelry necklace from the 1990s. I threw everything on, slicked back my hair, applied makeup as quickly as I could, and off I went. Five months later, I opened the September of *Vanity Fair* and saw a picture of me in this outfit on the Best Dressed List. If only they knew how much time actually went into that look!

There is a lesson here, in trusting your instincts and being willing to take a risk.

I would never advise someone to leave an outfit choice for an important event to the last minute on purpose. But if you have a strong sense of your own style and conviction of your choices, something great can come out of what on the surface seems like a nightmare scenario.

19.
FASHION PRESCRIPTIONS FOR DIFFERENT MOODS

READY FOR ANYTHING

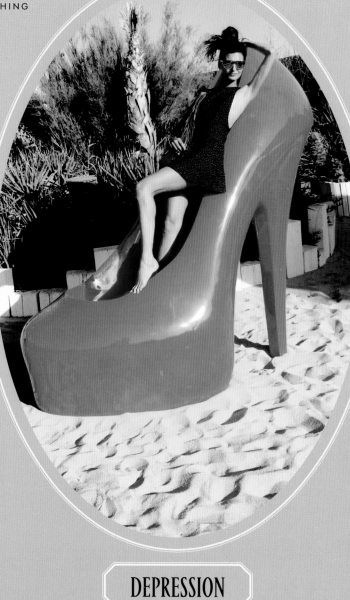

DEPRESSION

FOR:

DEPRESSION

QUICK FIX: Administer high heels.

MINIMUM DOSAGE: Four inches. The higher the heel, the better the feel.

SIDE EFFECTS: A trail of red marks and blisters on your feet.

To avoid the latter, arm yourself with Band-Aids,

chin up, and keep on walking.

_____ _____
SUBSTITUTION PERMITTED DISPENSE AS WRITTEN

REFILL 1 2 3 4 _____

NO REFILLS VOID AFTER

FASHION PRESCRIPTIONS FOR DIFFERENT MOODS

READY FOR ANYTHING

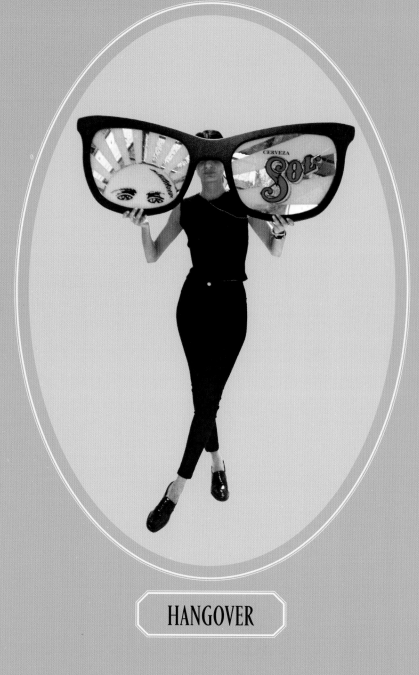

HANGOVER

FOR:

HANGOVER

QUICK FIX:

Find the biggest sunglasses you can. Apply to face immediately upon waking. Avoid harsh light for twelve hours at least.

SIDE EFFECTS:

Could be harmful when combined with the following: Amex, Visa, MasterCard, cash. Whatever you purchase will only prove harmful to yourself and those around you.

SUBSTITUTION PERMITTED

DISPENSE AS WRITTEN

REFILL 1 2 3 4 _____

NO REFILLS VOID AFTER

FASHION PRESCRIPTIONS FOR DIFFERENT MOODS

READY FOR ANYTHING

UNCONTROLLABLE ANGER

FOR:

UNCONTROLLABLE ANGER

QUICK FIX:

Every time you feel the urge to yell, try some deep
breathing while walking to the nearest accessories
store and buying yourself a beautiful handbag.
Do not use the bag as a weapon.

MAXIMUM DOSAGE:

N/A

SIDE EFFECTS:

Possible draining of bank account.

_____ _____
SUBSTITUTION PERMITTED DISPENSE AS WRITTEN

REFILL I 2 3 4 _____

NO REFILLS VOID AFTER

FASHION PRESCRIPTIONS FOR DIFFERENT MOODS

READY FOR ANYTHING

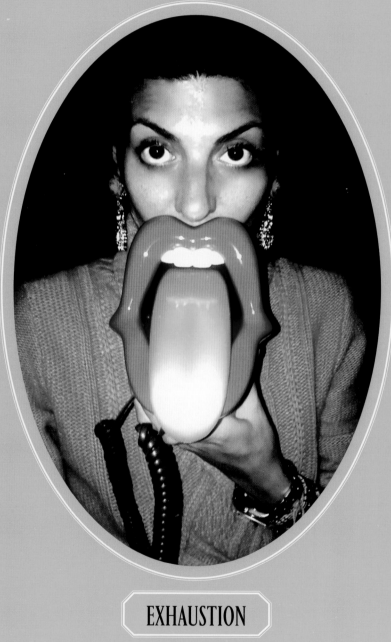

EXHAUSTION

FOR:

EXHAUSTION

QUICK FIX:

Apply red lipstick and administer flat shoes.

Add layers of cashmere, silk, and comfortable clothing.

MAXIMUM DOSAGE:

High-carat jewelry is recommended.

SIDE EFFECTS:

Do not mix with vodka, gin, champagne, tequila.

SUBSTITUTION PERMITTED

DISPENSE AS WRITTEN

REFILL 1 2 3 4 _____

NO REFILLS VOID AFTER

20.
GIO HAIR TO 'DOS

READY FOR ANYTHING

When Sid Vicious meets a tiara.
(Met gala)

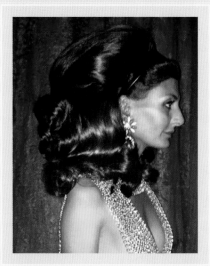

When Barbarella meets Hairspray—
the musical. (Saint-Moritz)

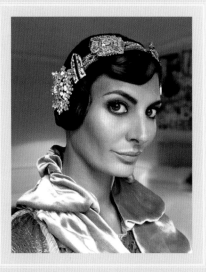

Great Gatsby meets Mata Hari in West Egg.
(Hamish Bowles birthday party)

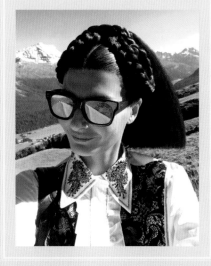

When Heidi Meets Cleopatra in Shibuya.
(Eugenie Niarchos birthday party)

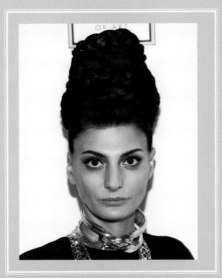

When Satyricon meets a snake charmer.
(Bergdorf Goodman anniversary party)

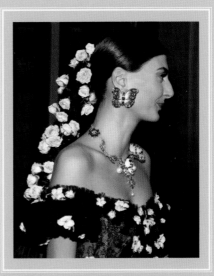

Elizabeth Taylor meets Fragonard.
(Met gala)

Chess piece meets a top knot.
(En route to a *W* magazine party)

Minnie Mouse meets a giant bow.
(Chanel Tribeca party)

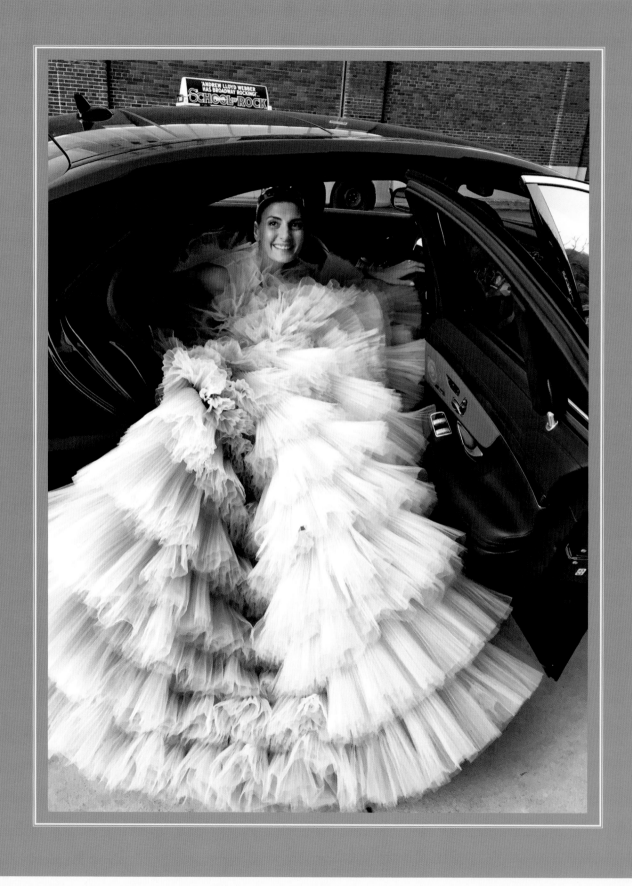

21.
HOW TO GO BIG
OR GO HOME

READY FOR ANYTHING

The most important person to please when you're picking an outfit is yourself. You can't think only about how others are going to perceive you or about making an entrance. When I wear a crazy look, I'm not thinking about what other people will think. I'm doing it out of a love of fashion and a sense of fun. My favorite place in the world to put on something fabulous and out-there is New York. Somehow, in New York, there's a license to wear whatever you want, whenever you want. There's a sense of freedom and a feeling that things can be outrageous.

And being outrageous—sometimes, not all of the time—can be fun and really get you into the mood for a big night.

For example, I had an enormous Giambattista Valli couture dress I wore to the Save Venice gala in New York. It was a dream dress—the second I saw it, I grabbed the first occasion I could find to wear it.

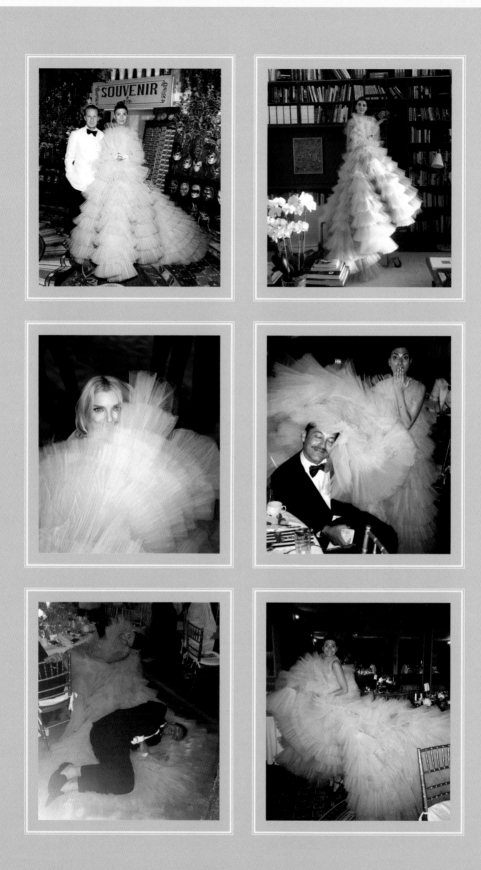

I knew it was a bit much for Save Venice. I even texted my friend Lauren Santo Domingo who was the host and asked, "Is this okay? Do you think it's too much? I'm too much anyway . . ." and she said, "Go for it, baby." And in a crazy way, it was the dress itself that kept me going the whole night. It felt grand, but also like a cloud.

Even though I wore it for myself, the best part was how people reacted to it. It made everybody smile. To me, that's so much fun; if you can make people smile with a dress, why not?

(And then people were tripping over my dress all night. Hilarious!) Getting to the party was certainly an endeavor: I had to enter my car backwards and then move very slowly through the door, like threading a needle. And then I folded the dress as much as I could and had the driver shove the rest of it in the car. Getting out, I had to move slowly to the door, and then sort of pop myself out of the car, like removing a cork from a bottle of champagne. But it was so worth it! I played hide and seek with Lily Donaldson; Enrique Murciano tried to use the skirt as a headpiece; and at dinner, Pietro Quaglia was my Sleeping Beauty. That's the thing with crazy ensembles: they require some effort. That's why you have to wear them for yourself. When you wear something outrageous, the key is feeling comfortable with yourself. But the final effect is a crazy outfit can lighten everyone's mood, not just yours. It really shows the power of fashion.

22.
HOW TO GO TO THE RESTROOM IN A GOWN

READY FOR ANYTHING

1. Move. In. Slow. Motion. Period.

2. Accept the fact that you're going to need help. The ideal scenario is if you can have a bathroom buddy, AKA a friend who can accompany you to the loo to help with zippers, hooks, eyes, etc. (Many bathrooms stalls are too small for two, so you will have to make a drastic choice: the gown or your friend.)

3. If you can't fit into the bathroom stall with your gown on, consider stepping out of it and either hang it up on the back of the door if there's a hook, come up with another spot to rest it on. If you're going to wear a big gown, you better be prepared to use your imagination throughout the night!

4. Prior to stepping out of your dress, be certain that you can get back into it. Consider practicing undoing and redoing your gown's various closures at home before going out for the night. (If you can't do it yourself, see point 2.)

5. Nip the problem in the bud: when wearing a difficult evening dress, avoid acting like an elephant, lapping up every beverage you see. Otherwise, you'll be running to the loo every five minutes!

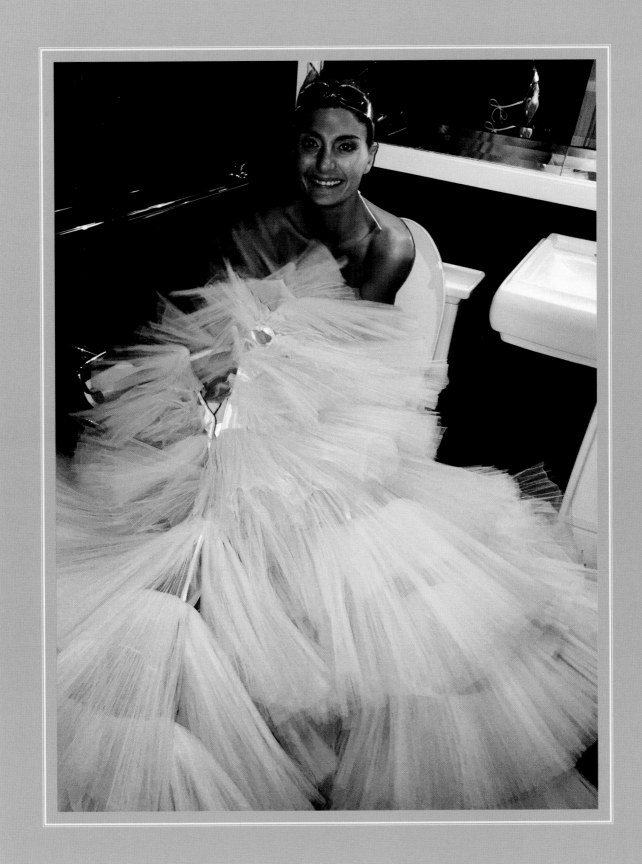

23.
INNER BOND GIRL

READY FOR ANYTHING

I grew up watching James Bond movies. From a young age, one of my dreams was always to be a Bond Girl. Now, every time I do a sport or activity that I consider crazy or more extreme, I think, "A Bond Girl would do it, so I have to do it no matter what."

I have a "What would a Bond Girl do?" mentality.

I consider myself outdoorsy, but not really an extreme sport person. I do what's necessary. But over the years, I've jet surfed with a dress on, driven a snowmobile in Iceland, and crossed a river on horseback in Africa, to name a few things. The thing with Bond Girls is they always look super chic or cool doing things. So I try to emulate that when I go on my own adventure: in Africa I was wearing an Eres one piece; in Iceland an orange jumpsuit; in the Virgin Island a sporty-chic bathing suit with goggles. Whenever I'm scared to do something, I dig in and find my inner Bond Girl and also the outfit to make it look fun. It helps me get over my fear and just do it. I've even boxed in Azzedine Alaïa. Why not? If Alaïa makes me feel good at a party, why not harness that power when boxing with a trainer?

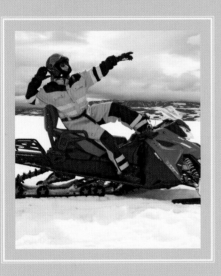

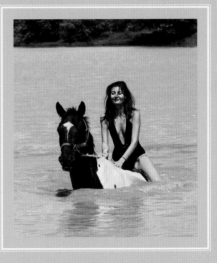

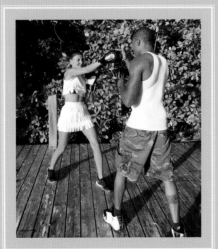

24.
ONCE UPON A TIME AT THE WHITE HOUSE

READY FOR ANYTHING

One day, as I was scanning my emails and I spotted one out of the corner of my eye: "WHO STATE DINNER . . ." It was in all caps—I later learned "WHO" stood for "White House"— so the email looked as though it might be fake, but just in case, I opened it. There in digital calligraphy were the words "President and Mrs. Obama request the pleasure of your company . . ." And then I saw the name Matteo Renzi—then the prime minister of Italy—and I realized: this was a real invitation to a White House state dinner. The last state dinner of Obama's presidency, it happened to honor the Italian prime minister. And I made the guest list. How was this possible?

The invitation arrived eleven days before the dinner, during which time I would be traveling to New York, Moscow, Sweden, and then back to New York. How on earth was I going to find something to wear? It was the most challenging fashion predicament I had ever faced: for a dinner of this magnitude, I needed something that wasn't too "fashion," that I hadn't worn before, that looked presidential (whatever that meant), and was something I owned so I could have a sartorial souvenir from the evening. I searched through fashion shows online, looking for something appropriate with a twist, but it was all too sheer, or too fashion, or too boring. Oh, and of course it had to be an Italian designer!

My top choice, of course, was Giorgio Armani—who I later discovered was also invited. When you think of timeless Italian elegance and how it's represented in America, you think of Armani. He was the first Italian designer to be on the cover of Time magazine, in 1982, with the headline "Giorgio's Gorgeous Style." For a moment, I considered wearing the couture Valentino gown I had worn to the civil ceremony of my wedding earlier in the year. I had been to an event at Buckingham Palace a couple of weeks before I received the state dinner invitation, so when my mother—whom I'd called to ask for advice—balked at

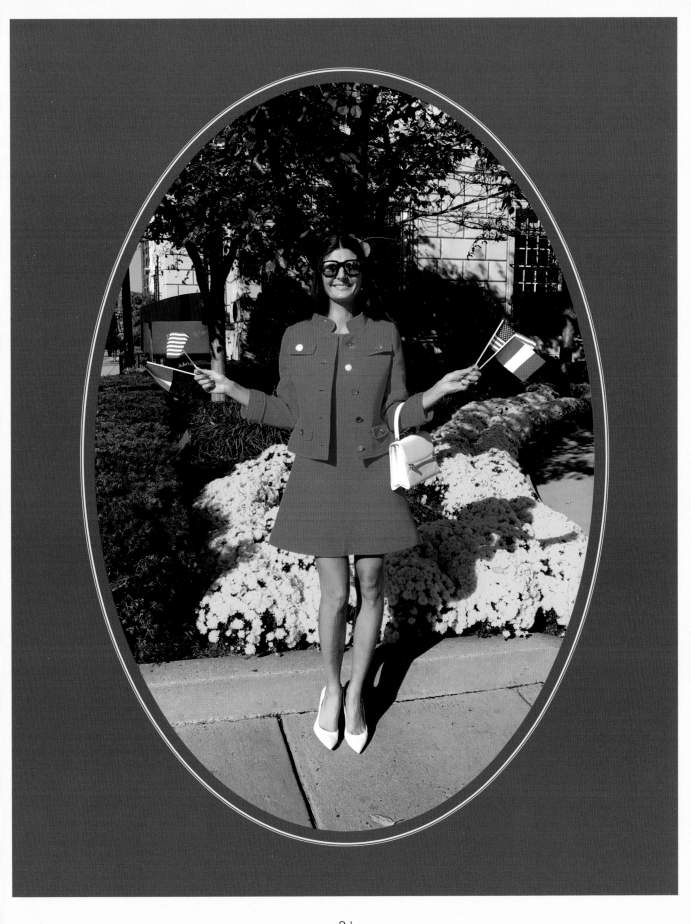

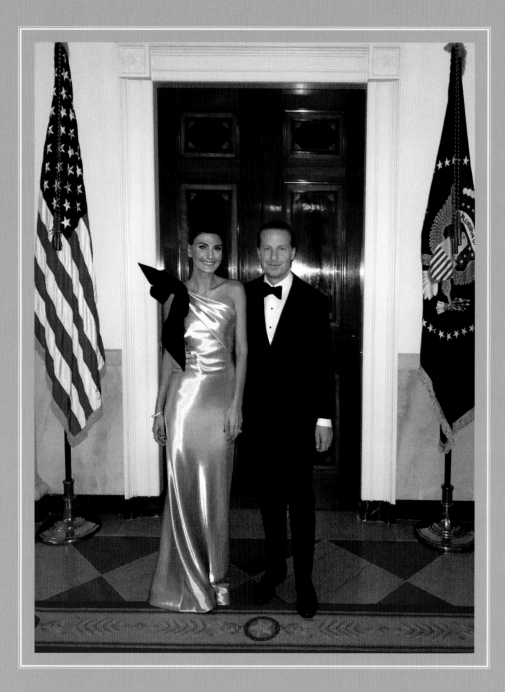

my choosing a wedding gown I said, "When I was at Buckingham Palace, I learned that the Queen of England even wears the same outfits more than once." "It's good you have a very normal reference," she replied. She was right, of course: it was too much for me to wear a wedding dress to an event at which I was a guest, not the honoree!

And Armani was really the perfect way to go. There was one Armani Privé look, a gorgeous cream silk charmeuse gown with a black velvet bow detail from the most recent show that I thought might fit me. It was truly the only one. After some emails with the team at Armani, they sent me a message saying, "Mr. Armani is going to the state dinner. And we are going to make the dress for you." I was in Stockholm when the dress arrived, hand carried by someone from London. I tried it on the second it came, but the corset was too small. My husband, Oscar, managed to get it to fit.

The event was preceded by an arrival ceremony, at nine the morning of the dinner. "Dress accordingly," the email instructed (the same direction given for the state dinner!). My head did a mental spin through my closets. Yes, it's in the morning—but I'm me and I wasn't going to wear a blazer and jeans! Thankfully, Oscar had recently bought me a very Jackie Kennedy–esque couture Courrèges skirt suit. I paired it with white velvet Gianvito Rossi stilettos and a vintage white Gucci purse—an homage to Jackie and her famous Gucci bag.

The morning of the arrival ceremony in Washington D.C., a crisp, blue, perfect fall day, Oscar and I got to the White House an hour and a half early to nab the best seats on the grassy lawn. It turned out that my Gianvito Rossi heels were not very compatible with the terrain—my heels kept sinking into the grass and I had to rock back and forth to keep from getting fully stuck. But I refused to give up my spot! There were American and Italian flags everywhere and an impeccable military procession and then we heard drums and a booming voice introducing President and Mrs. Obama. They came through a set of doors to the White House and took to a stage, the picture of regal poise.

After the arrival ceremony, Oscar and I headed back to the hotel and later that afternoon, I started getting ready for the dinner. I was so excited to wear my Armani gown! But my body, on the other hand, was having some issues with the designer. The corset was so tight that I could feel the boning sticking into me. I was in pain in my hotel room—how was I going to last through the whole

night? My assistant Kelsey had the brilliant idea of covering the entire inner waist band with my trusted Compeeds to cushion the boning. It still hurt, but it had the aesthetic benefit of making my waist look even tinier!

We arrived at the White House to be greeted by a labyrinth of security. Once through the many stations, we were inside the storied building, seeing portraits of past presidents and three boys singing as guests walked by. I thought, "Wow, I am in the White House!" After passing a group of photographers, we entered a series of rooms, among them a library and the famous Vermeil Room with its First Lady portraits—I had to pose with the portrait of Jackie Kennedy! Servers in the chicest red military uniforms offered glasses of champagne. And even though everything felt immensely formal and grand, as if we were wandering the corridors of a castle, it also felt strangely intimate. I was in someone's home!

The more official cocktail hour was in the State Dining Room, since the dinner was outside under a tent, so we made our way up a marble staircase. The State Dining Room was so elegant: all opulent chandeliers and gorgeous crystal and pink and green and white floral arrangements—so chic! And I could feel the ghosts of past state dinners in that room. I got a vodka on the rocks from the bar and took in everything, knowing this was a once-in-a-lifetime experience. The colors and fabrics (that moiré!) were so elegant.

The line to meet the President and Mrs. Obama snaked through the Green Room—whose curtains and tassels I was obsessed with!—and into the Red Room, where they were standing. (I knew it was the Red Room from my sister, Sara, who is a big fan of *House of Cards*!) As we approached the Red Room, I realized, "Oh my god, this is really happening! I'm about to shake the hand of President Obama." And I'm not normally impressed by celebrities. But the whole package together—his insane presence, the importance of his presidency in American culture—it felt as though I were meeting a piece of history that has been centuries in the making.

When we had first gotten in line, we had received a card with our names written on it. At the entrance to the Red Room, we each gave our card to an impeccably uniformed man. And someone boomed, "Giovanna Battaglia and Oscar Engelbert," as though we'd been transported a hundred years back in society. And I didn't know what to say, so when I approached President Obama, I started speaking in Italian! *"Buona sera, questo e' fantastico!"* I said. Obama laughed and replied, "What is your name, young woman?" I was at such a

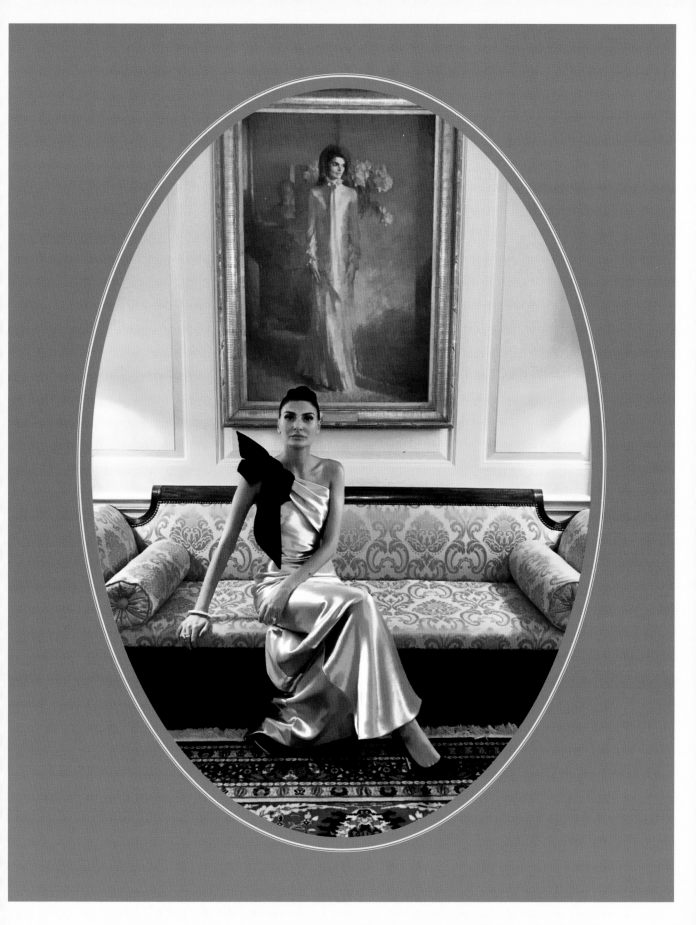

loss for words that I just said, "I'm Giovanna and this is my husband," and we moved on to greet Matteo Renzi, which was a bit more comfortable for me as I'd met him when he was the mayor of Florence. But then next to him was Michelle Obama. It was the first time I had seen Mrs. Obama in person that night. And in her Versace rose-gold dress she was like a ray of pink metallic light, so tall and beautiful and with so much charisma. I couldn't help it—I said, "Wowwwww!" It was so loud that she heard me and laughed. And then she held out her two hands, as though to clasp mine. I lost all sense of decorum and I hugged her and kissed her. Twice. Like a good Italian. I kissed Michelle Obama! And then Oscar did the same! Even I know you're not supposed to do that. Ever. But she was so warm about it.

Then we exited the White House building and headed to dinner in the cutest little garden buses, with a brief detour to visit Mrs. Obama's gorgeous vegetable garden. It was quite a sight to see all these women in glamorous gowns admiring her vegetables! Once we entered the dinner tent, we heard an orchestra playing the most incredible, happy music underneath chandeliers woven through with greenery. President Obama gave a welcoming speech, and when he got to the line, "Your presence here tonight shows that America's a place where if you work hard, no matter what you look like, what your last name is, how many vowels you have in your name, you can make it if you try," I started crying. I kept thinking about how ever since my move here, I had never stopped working for a second. And luckily, it has paid off.

When I moved to this country in 2010, people could barely pronounce my name. Six years later, I was sitting in a tent at the White House at the last state dinner ever for President Obama. At my table was a person from Michelle Obama's office who told me, "When we were putting together the list of Italians in America who should attend, we couldn't not have you." My mind raced back to when I was on my flight from Milan to New York wondering if I was making the biggest mistake of my life by moving to the United States. You have to understand—to an Italian, leaving your family and friends behind is a big deal and extremely difficult. It was a risk. But you have to take a leap sometimes. America is a country that gives you the possibility to make something for yourself if you want to. And I did and I got my American dream.

Oh, and there was a happy ending, fashion-wise, too. Mr. Armani was so pleased that I wore his dress that he said he would make me one as a gift—in my size!

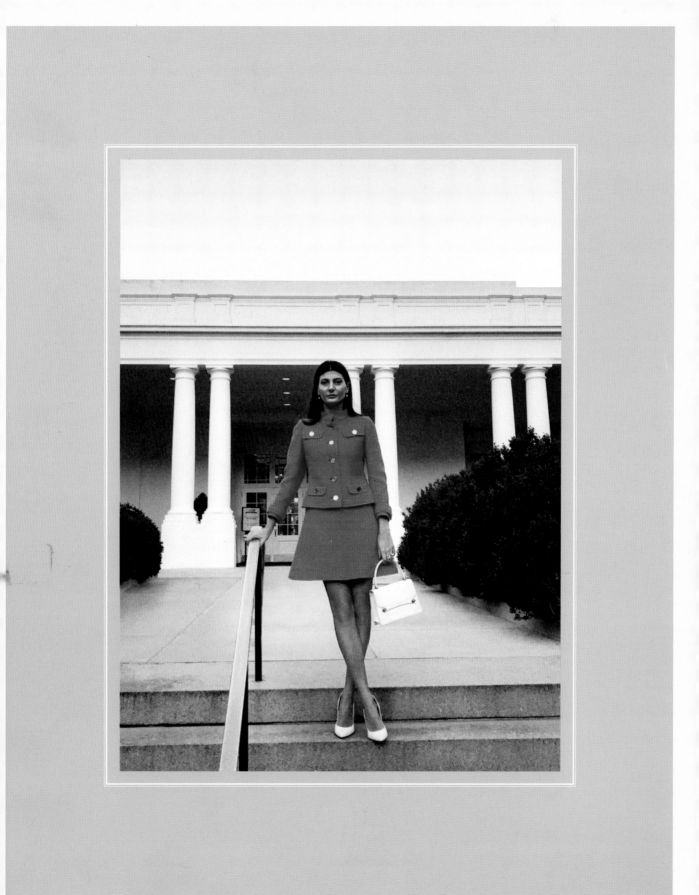

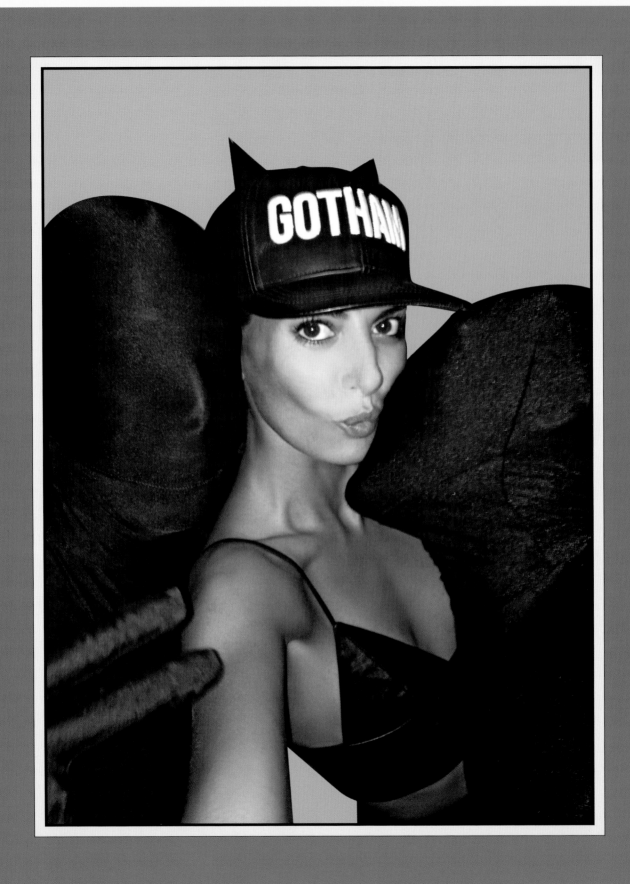

3

ABOUT
LAST NIGHT

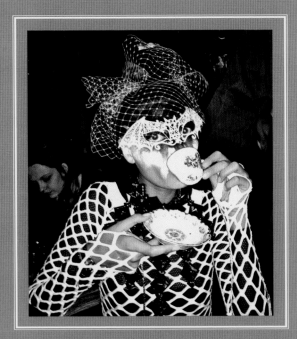

Bat Teacup

Wrap full body in a maxi white fishnet.
Add vodka to tea cup and sip all night.

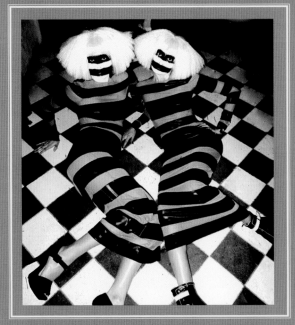

Blade Runner 2.0

Squeeze two Bat sisters into a pair of
clingy striped Norma Kamali dresses.

The Dark Knight Rises

Take thirty inches of black leather and wrap
around chest, fixing in place with a buckle.

Bathroom Bandleaders

Locate two vintage jackets, two pairs
of knee-high boots, and one sibling.

25.
THEME PARTY RECIPES

Halloween isn't a big thing in Italy, or at least it wasn't when I was a kid. The closest thing I had to Halloween as a child was Carnevale, a holiday in February where you put on crazy costumes (though not scary ones). When I moved to America, I realized what a big deal Halloween is here. And while I am not a fan of zombies and fake blood and monsters—essentially, the horror side of the holiday—I am, obviously, a huge proponent of any occasion that calls for dressing imaginatively! It should be no surprise, then, that I don't think costume-inspired outfits should be limited to just one day of a year.

That's where theme parties come in: you can create a persona that's more exaggerated than everyday outfitting. I just love dressing up for anything with a theme!

Over the years, my costumes have been painstaking and very involved, taking inspiration from pop culture, films, art, and fashion. I'm not trying to hide who I am: it's more about amplifying myself into a crazy character who is a mix of ingredients that, somehow, come together in a fun, entertaining way. At the end of the day, they are all extreme, extravagant versions of my own personality.

GOLDEN MIDSUMMER NIGHT DREAMS

START

Take six meters of fluid gold silk. Stir until smooth.

GARNISH

When nighttime falls, pour over body until it reaches
consistency of a For Restless Sleepers pajama set.

SERVE

Top with a matching golden laurel.

THEME PARTY RECIPES

ABOUT LAST NIGHT

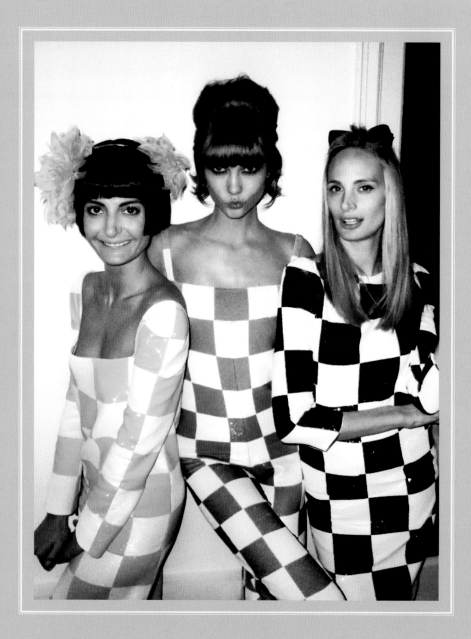

1960S CHECK MATE

START

Take a lemon-check Louis Vuitton gown.

GARNISH

Add one Peggy Moffitt wig.

SERVE

Finish with a yellow-lime organza flower
tucked above each ear. Must be consumed with
Karlie Kloss and Lauren Santo Domingo.

DEREK BLASBERG'S BIRTHDAY
IN NEW YORK CITY

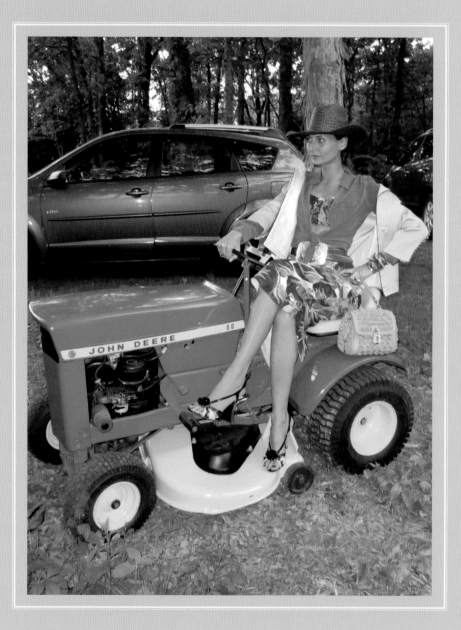

ST. LOUIS ITALIAN FARMER HOUSEWIFE

START

Take one bushel of ripe eggplants, and mix with a skirt.

GARNISH

Add a Prada Elvis Presley and Swarovski bomber jacket.

SERVE

Finish with a bright green handmade crochet
Dolce & Gabbana handbag and Prada Cadillac shoes.

DEREK BLASBERG'S 30TH BIRTHDAY
IN ST LOUIS, MISSOURI

THEME PARTY RECIPES

ABOUT LAST NIGHT

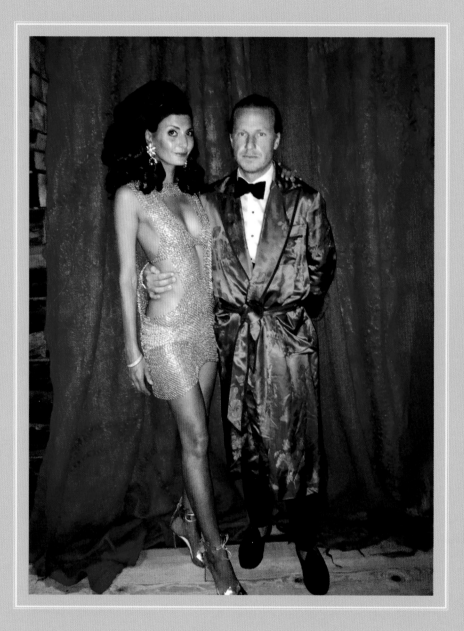

OSCAR WILDE AND A
BARBARELLA PLAYBOY BUNNY

START

Fill a bowl with ten pounds of gold chains.
Apply delicately to body—just enough to cover
the most essential parts.

GARNISH

Take three wigs, set aside until they rise to twice their
volume. Cover in lots of hairspray and place on head.

SERVE

Pair with a handsome husband in an emerald robe.

EUGENIE NIARCHOS' BIRTHDAY
IN SAINT MORITZ, SWITZERLAND

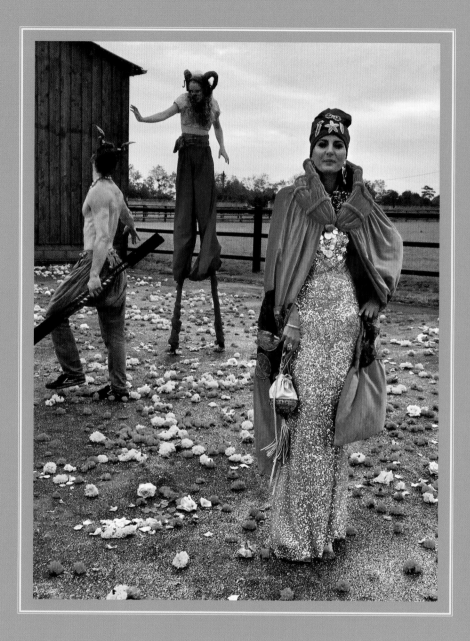

BALLET RUSSES MAHARAJA DIVA

START

Measure five kilos of sparkly gold sequins.
Pour over body.

Wrap a thick layer of deep orange velvet around
shoulders.

Set aside a purple Prada turban.

GARNISH

Cover turban evenly with bejeweled brooches.
Apply mixture to head.

SERVE

Finish with one golden pouch bag and seven kilos
of more-is-more attitude.

26.
MORNING AFTER TREATMENTS

ABOUT LAST NIGHT

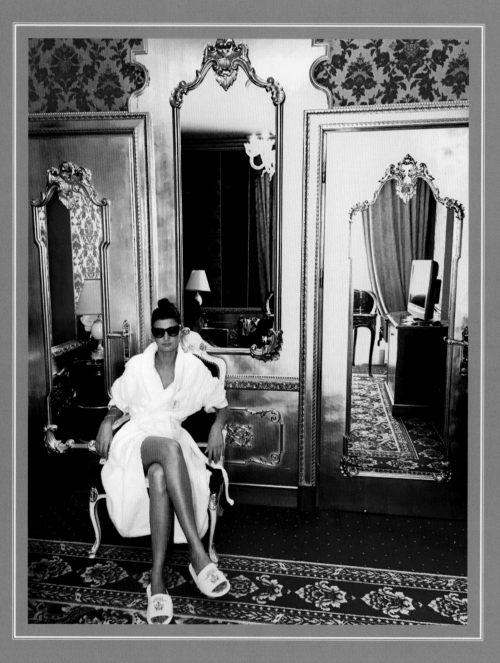

RUSSIAN PLATZA

If your hangover isn't so bad that it puts you in your grave, this will bring you back to planet Earth. Beware: this Russian treatment is more boot camp than bliss out.

A MOROCCAN HAMMAM

After a super-intense workweek, there's nothing better than an equally intense scrubbing treatment—it gets rid of both dead skin cells and all of the stress and negative people in your way, leaving you ready to go out and enjoy life.

FACIAL MASSAGE

There's no amount of sleep deprivation a session of this can't correct: a meticulous facial massage and manual pinching technique make you look as though you're wide awake and have plenty of energy to party all night.

SK-II SHEET MASK

The morning after a long and tough night, if you don't have the luxury of sleeping in, this mask is amazing at returning some good ingredients back into your skin, particularly because it doesn't include alcohol.

SK-II EYE MASKS

I like to stick these on while I'm getting dressed to go out, before I put my makeup on. They remove all traces of dark circles and irritation—and it doesn't hurt that they smell amazing.

PURE GINGER SHOT

This will take you up to space and back. If you can survive this, you are ready for anything the day will bring.

DOPPIO-PLUS-ONE ESPRESSO SHOT

Sometimes, the only thing you can do is drink caffeine and pray for the best.

AVOCADO

In any form—it's great for settling the stomach.

BAKERY

Run to the nearest boulangerie you can find—carbs cure everything.

27.
DANCING ON TABLES

ABOUT LAST NIGHT

Dancing on a table is the ultimate expression of joy, spontaneity, and confidence. It is something that happens in the moment: you're feeling the music, your friends, and the mood of the room—and suddenly, the urge strikes. That said, there are important guidelines to keep in mind in advance so your table adventure doesn't turn into a trip to the ER.

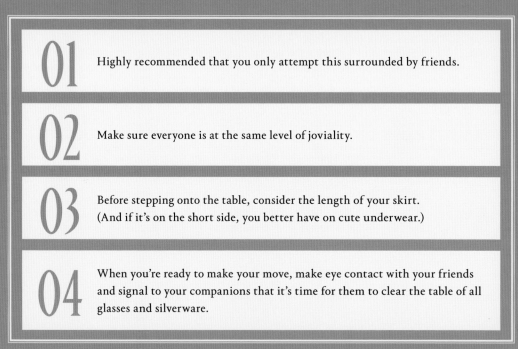

01 Highly recommended that you only attempt this surrounded by friends.

02 Make sure everyone is at the same level of joviality.

03 Before stepping onto the table, consider the length of your skirt. (And if it's on the short side, you better have on cute underwear.)

04 When you're ready to make your move, make eye contact with your friends and signal to your companions that it's time for them to clear the table of all glasses and silverware.

05 If you insist upon keeping your heels on, make sure you feel very stable and balanced in them. True devotees, however, take off their shoes and get on the tables barefoot—it's much chicer.

06 Once on the table, let your inner *la dolce vita* spirit come out. Dance like nobody's watching—but keep it classy.

07 Do not confuse table dancing with pole dancing—the latter is for a very different scenario.

08 Take your cues from the party's soundtrack—vintage or local music is ideal.

09 Very important: do not spill your drink. Either place it to the side before you get up—and not on the table on which you're standing—or hold it carefully.

10 Choose your partner(s) wisely: you don't want anyone so drunk that he or she will drag you down, literally.

11 The more the merrier—until the table breaks.

28.
PARTY
PROPS

It's easy to turn the most mundane night into something irreverent and special. You just need to tap into your childlike sensibilities.

Even something as simple as a napkin in a restaurant can become a party objet that keeps your fellow playmates entertained for hours.

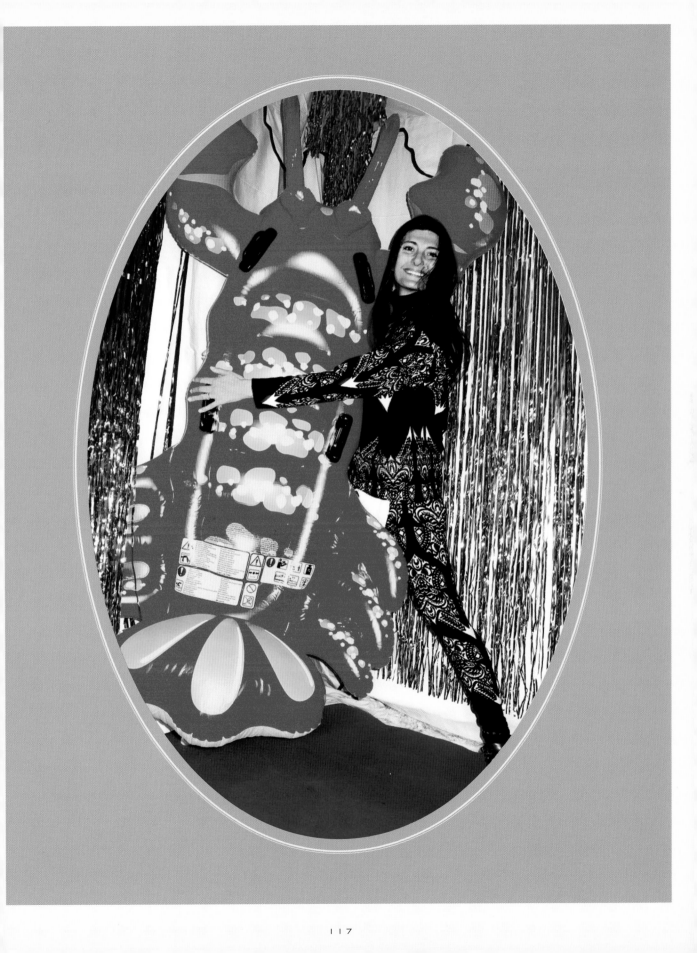

PARTY PROPS

SARAN WRAP

If you're feeling particularly affectionate toward your dancing partner, why not take the relationship to the next level by wrapping yourselves together with Saran wrap?

ANIMAL HANDPIECE

Guarantteed to shake up a British aristocratic-themed dinner.

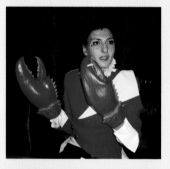

NAPKIN

Napkins are the perfect party accessory—they can be configured into all manner of headdresses. For a richer experience, try connecting more than one napkin and person simultaneously. You can go from a nun to an Easter bunny to a babushka in the space of one course.

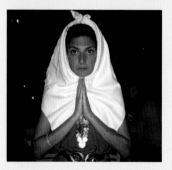

FIRE EXTINGUISHER

When the party's on fire, take a stroll with the nearest extinguisher.

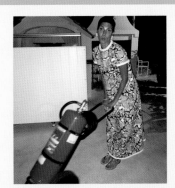

ANTLERS

If you spot a particularly photogenic twig on the ground, feel free to pick it up and use it as makeshift antlers.

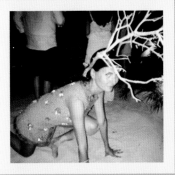

PAPER TOWEL

A longtime tradition of me and my friends is stealing rolls of paper towels from the bathrooms of clubs. You need two people, at least, to make this work. One person holds the roll, while the other unravels it from behind, creating a garland effect throughout the club.

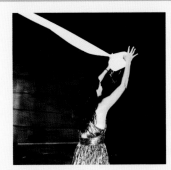

CLOWN WIG

Party costumes are even more fun in unexpected places. Perhaps the most unusual would be a desert island in the Caribbean. Suddenly, a clown wig or Cleopatra getup takes on a whole new level of silliness and exuberance.

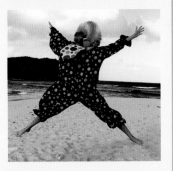

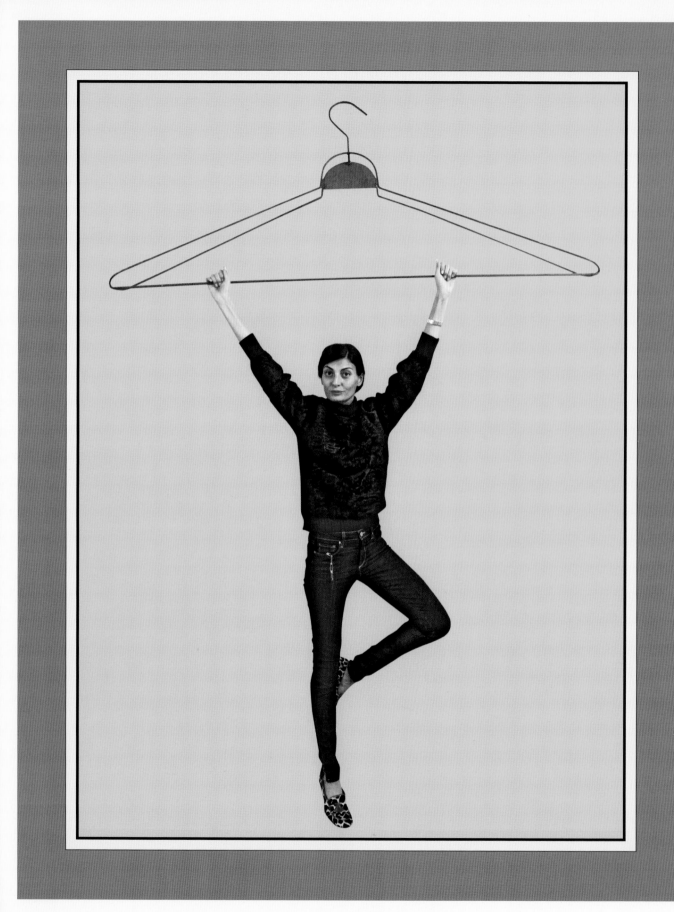

4

WORKING GIRL

29.
HOW TO DRESS FOR A CRUCIAL BUSINESS MEETING

WORKING GIRL

01 Get a good night's sleep. Plan ahead to avoid any nocturnal activities the night before the big day, particularly if they involve alcohol, dancing in towering heels, and/or a one a.m. pizza run.

02 Wake up an hour earlier than usual. This will give you time to consider the weather and plan your outfit, hair, and makeup accordingly.

03 Caffeine—followed by a cinnamon Altoids to avoid coffee breath.

04 Music is key. Turn on some power songs or upbeat pop—know what you need to get in your zone and tailor your soundtrack accordingly.

05 Wear something colorful but not too loud. Avoid light silk because it's fragile and it wrinkles. Stick with more substantial materials like wool crepe and jersey, because they don't crease. A blazer is a solid choice that will make you feel empowered and make your shoulders look strong and straight. Your look should be sharp, simple, and glamorous.

06 This isn't the art of the seduction. Skirts shouldn't be too short—keep it to the knees. Pants can be tight as long as they cannot be mistaken for leggings. If you choose a dress, keep your chest in, not out.

07 If your meeting is with someone well informed in the realm of fashion, do not wear a designer outfit whose season is immediately recognizable, especially if you're not wearing the current season!

08 Always wear some sort of heel, because it gives you better posture. Don't wear platforms—it doesn't look professional. Never wear a pair of shoes that you haven't broken in. You will end up in pain, which will disrupt the flow of blood to your brain.

09 Groomed hair is a must. A side part is universally flattering. Make sure it's razor sharp and straight.

10 Keep your makeup minimal. Aim to look like the freshest and most beautiful version of yourself—no one should even notice you have makeup on. (Keep in mind, though, that achieving this "natural" look may take twice as long.) No lip gloss—it's shiny and distracting.

11 No funny business on your nails, which includes weird colors. This is not the time to show off your love of Mondrian above your cuticles.

12 Always take an SUV to the meeting—it's better for your self-esteem to be higher than the other cars on the road.

30.
STYLIST
KITS

WORKING GIRL

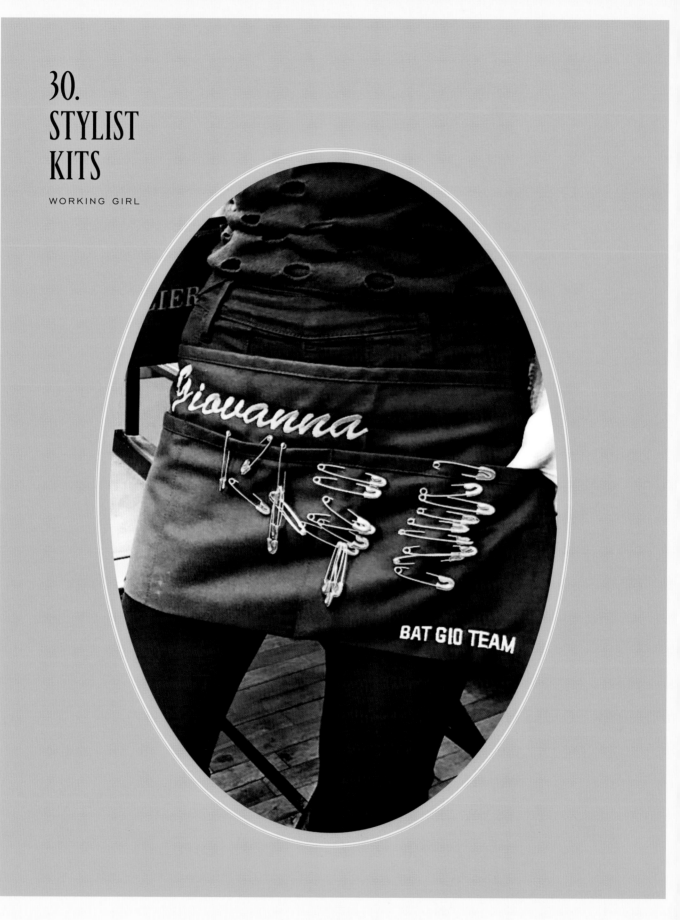

A stylist's work kit is like a mobile home with the most unconventional décor. Inside, you will find all manner of remedies for concerns you didn't even know existed. It's a living, breathing organism in the way it continues to expand and collect new items. I would say it was probably a decade ago when I first moved beyond the basic, starter items—safety pins, etc.—to a more multifunctional enterprise. I was on the set of a commercial for Jaguar, a big production, and I was helping out the woman responsible for costuming all of the extras. I saw her kit brimming with stuff, with a whole section devoted solely to different stain removers and even deodorant (it had never occurred to me to carry that for someone else) and I was like,

"Your kit is bigger than mine!"

It was so fascinating to see how many objects the woman had meticulously separated into labeled plastic containers—including every permutation and size and material of fake boob known to humankind. Since then, I've expanded my repertoire. Sometimes I have five to six trunks worth of things with me! As a stylist, you will never lack for new and seemingly impossible problems you need to solve, particularly if you are on a location shoot (as opposed to one happening indoors in a studio) where you and the model are at the mercy of weather, terrain, and light changes, among other issues. So you have to be prepared for everything.

I've done shoots on a glacier in Italy and lugged things up to the top of a mountain on a snowmobile.

The more experience you have, the more you end up adding to the kit. Say you do a shoot where everyone is freezing. Afterward you think, "Oh, I never want to be freezing cold again!" and so you add in something to keep both you and the models warm. Also, I tend to have a very "Italian mama" vibe: I'm always thinking about the models and how I can take care of them. I have Band-Aids in case they cut themselves as well as things to keep them comfortable in different temperatures. I also have ribbons, simply because I love ribbons and seeing them makes me feel better (even if I never end up using them!). Everything is super organized, in its own little bag. I suppose it's a bit like my version of a very tidy garage. I'm a fashion repair guy. And the best part is I never stop learning.

31.
FASHION
WORKER

WORKING GIRL

In 2014, I was in Capri styling a story for *Vogue Japan*, photographed by Boo George. There was a particularly extravagant Dolce & Gabbana Alta Moda couture gown that my editor Anna Dello Russo and I wanted to include and, of course, I had chosen as the setting a rock in the middle of the water a little ways out from the shore. In order to get there, you had to jump from one rock to another and the gown was so big that it took five people jumping from rock to rock, passing it over their heads one by one, to get it to the rock safely. Then the model, Nadja Bender, followed suit, jumping from rock to rock in just her underwear and a bra before putting on the dress.

The point of the shot that we wanted was to show how majestic the gown was.

But, as Mother Nature would have it, once Nadja was finally in place, the wind started blowing from behind her, deflating the dress like a flat soufflé. So I jumped out to Nadja's perch on the rock and then crawled under her dress, crouching into a shape that puffed the skirt out into the voluminous silhouette we wanted. A few clicks later, we had the shot! This is only one of countless crazy things I have done to achieve the perfect picture in my career as a stylist and fashion editor. I've also run through a Russian park in freezing temperatures with the model Lindsey Wixson and the photographer Emma Summerton, chased by security guards claiming we didn't have the correct permits. I once worked with Max Vadukul to photograph twenty indie bands at the Glastonbury Festival, styling over fifty people over the course of three days, all of whom were in various stages of drunkenness. In Puglia, I chased down chickens who refused to stay put for a wedding being shot in a small village. For a jewelry story, I once dealt with a small dog who took off from the bedroom set wearing a million-dollar choker around his neck. The list goes on.

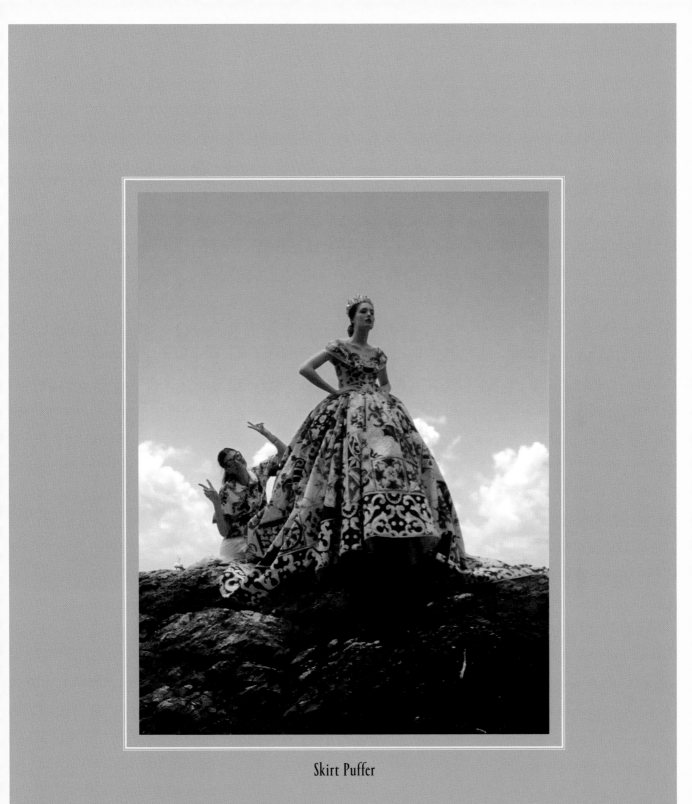

Skirt Puffer

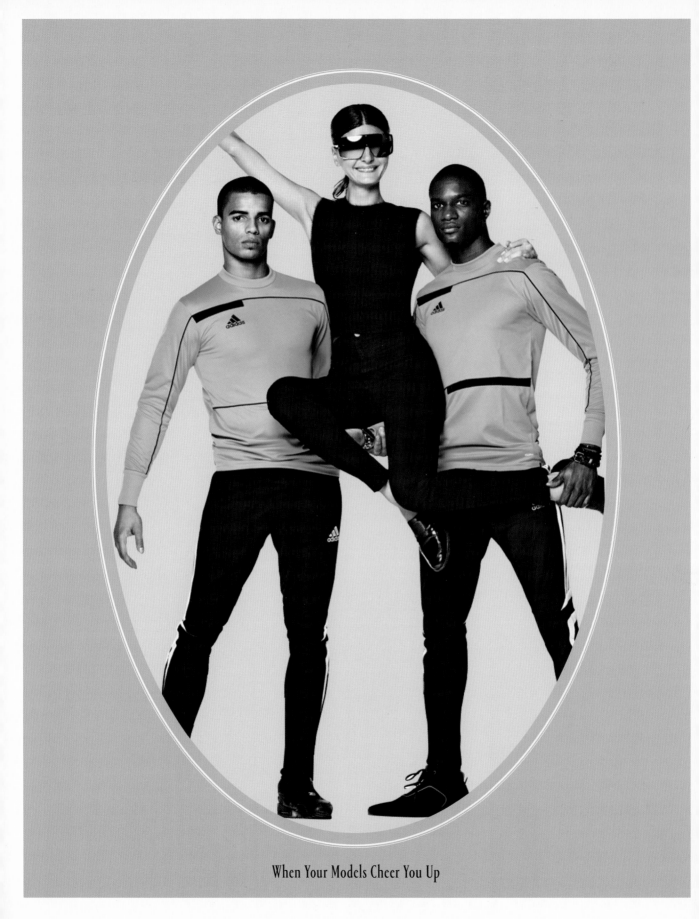

When Your Models Cheer You Up

You have to bring the pictures home. I could hardly have imagined that this would be my life when I first started working in the fashion industry in my hometown of Milan at seventeen years old. I was a model; I didn't know what a stylist was at that time, as then it wasn't such a common term. People thought stylists were designers. (And even when I started styling years later, people still thought my job was about sewing.) Now, we (and I) know that stylists are people who tell stories with clothing.

We're dream weavers who use fashion, in conjunction with hair and makeup and photography, to tell a tale.

I'd always loved the art of dressing up and putting clothes together—but it didn't take me very long to realize I didn't want to be a model. Even at that age, I knew I had more of an editor's eye than a model's constitution. Still, modeling helped me a lot because it made me financially independent at a very young age. And it also helped me learn how to navigate the fashion world. My mother was very protective of me—she wouldn't let me leave Milan and share an apartment with other models. So I stayed in Italy until I was eighteen. When I finally got to go to New York for a photo shoot, I got to the set and went into hair and makeup and it was just terrible, so I said, "What is this?" And then I saw the clothes and they were awful too, so I told the editor that as well. Not surprisingly, they fired me. I was sad for about five minutes and then I went shopping. My agent called me and was like, "What happened?" I said, "They told me to go." And she was like, "What do you mean they told you to go?" And I said, "I told them I didn't like the hair and makeup or the clothes." That was my modeling career in New York. It lasted five minutes! Back in Milan, I met the stylist Charlotte Stockdale. As I spent time around her, I slowly realized that hers was the job I liked most. I knew I wanted a job where I could combine my passion for moving images with my love of history, music, aesthetics, traveling, and the arts. But I still didn't really know what being a stylist meant. So at one point I said to Charlotte, "Can I be your assistant?" And she said, "No, you need to just start on your own." But I did assist her on one job, helping Italian designers get their models into the looks. Of course, I knew all of the models from my own work as a model.

They were all like, "What are you doing here?" I got to boss them all around. I loved it!

My first editorial job was for a very alternative magazine in Italy called *Pig*. I just showed up and said, "I want to do a shoot with you." It was an outer-space-inspired story. I figured everything out myself, paying for every mistake with my own money and energy. I used all the money I'd put away from modeling to support myself for the next three and a half years. Because I had been a model, it took a long time for people to understand that I wasn't just pretending.

The turning point was when Anna Dello Russo asked me to work with her at *L'Uomo Vogue*. We knew each other socially, and one we bumped into each other on a boat from Stromboli. "So, Giovanna, you're serious about being a stylist?" she asked. "Would you do menswear?" I was impressed that she knew I was doing something, because she was this legendary fashion editor. So I told her, "If it was with you, I would do *Vogue Dog*!" I started with *L'Uomo Vogue* in the summer of 2003. Working as a fashion editor changed everything for me. A stylist is really only focused on the clothes, which is great fun and something I love. But being a fashion editor broadens the scope. Suddenly, instead of only thinking about what looks to shoot, I was also considering the hair, the makeup, the photographer, and, most importantly, how the story I was doing fit with the magazine's overall aesthetic and message. It's tough, because you have a world of rules to abide by—what works for *Vogue* may not be right for another publication. But it's a great responsibility to have and it made me proud. I loved representing the *Vogue* brand. It was like becoming a member of the major leagues. Fashion editors are similar to movie directors: instead of films, they make stories; instead of actors, they have models; instead of a DP, they have photographers. It was thrilling to think about the needs of a magazine and the audience that would take in my work.

A few years later, Anna left Condé Nast. I felt a bit orphaned, but I stayed and eventually, I started working for other international Condé Nast publications and even coming to New York for some jobs. I did *Vogue Jewelry and Accessories* for a few years. It was an amazing opportunity and I was so grateful to Franca for the experience. But I was also feeling a bit claustrophobic in Italy. I wanted more than I could achieve there. And so, as with any relationship that has been important but run its course, I left and decided to go play in a bigger pool. I'd loved New York all of my life and I felt that if I wanted to become a better stylist, I needed to have a full experience in New York. New York is the number-one city for media and I needed to go there to achieve the global vision I craved. If you want to succeed, especially in fashion, you have to take risks. Luckily, it paid off.

When You Feel Dead After Work

32.
FASHION PIT STOP

WORKING GIRL

I've always wished that I had a group of people around me, like a team at a pit stop in Formula One racing, who could help me with my outfit changes. How fantastic would that be? Even better would be if I had a copilot who could help me out with all the requirements of my day: one for work, one for a work cocktail party, and one for a fun event.

CIRCUIT: OFFICE TO WORK COCKTAIL

GARAGE
Your fluorescent-light-lit, multiple-stall office bathroom—good luck!

MECHANICAL ADJUSTMENTS
Wear the same dress from the morning—think of it as your fashion all-wheel drive because it works in every scenario. Swap out your tote for a smaller clutch.

CHANGE OF TIRES
From your go-to-pump or your office loafers to really glam, high-heel shoes that make you happy and will lift your spirits.

REFUELING
A handful of almonds if you are organized enough to have snacks at your desk. Or, if you are particularly tired and in need of a quick jolt of energy, perhaps a quick sugar fix from the nearest vending machine.

REPAIRS
Take advantage of the horribly unflattering lighting in the aforementioned bathroom, knowing you will never look worse than you do in this moment.

CIRCUIT: FASHION WEEK ALL-NIGHTER

GARAGE
Hopefully your hotel room because you're traveling.

MECHANICAL ADJUSTMENTS
Shower. You have to rinse off the night of work and try to decompress.
And then head straight to bed. Set four different alarms, five minutes apart.
Make sure at least one of the alarms is out of reach of the bed, requiring you
to get out of bed to turn it off. Pro move: Preorder room-service coffee before
getting into bed, which will serve two purposes—waking you up by forcing
you to answer the door and providing a much needed source of caffeine
(see "Refueling" below).

CHANGE OF TIRES
Pajamas. It really helps to have on something super comfortable, even if only
for fifteen or twenty minutes. It's like a safety blanket that helps reset your brain.

REFUELING
Full tank of coffee, extra strong.

REPAIRS
Cold shower for at least ten seconds (bonus: it tightens your pores). Put on
an outfit with confidence-boosting tailoring (say, a great blazer) but that is
comfortable enough to ease you into the day after no real sleep. Preferably, it
should be one you have laid out after your hot shower before getting into bed.
It needs to be structured enough to keep you alert, but not to the point of
fitting like a straitjacket. You will probably feel as if you have been run over by
a car, so consider your hair and makeup to be like collision-repair techniques:
a high and tight hairdo will keep you sharp; concealer and mascara will cover
the most basic damage.

CIRCUIT: OVERNIGHT FLIGHT TO MEETING

GARAGE
Airplane lavatory. Size and quality of lighting will depend on the airline and the class of flight you have chosen.

MECHANICAL ADJUSTMENTS
Your second look has to be simple. Always go with a dress—it has to be anti-wrinkle and small because it has to fit in a carry-on. And it has to be the simplest thing to put on. Cover the sink counter in paper towels. Lay the dress out on top. And then contort your body as needed to make sure nothing important touches the questionably hygienic bathroom floor or surfaces.

CHANGE OF TIRES
Swap out your travel shoes or slippers for nice flats because you need to be prepared to walk a lot in the airport once you hit the ground (not to mention your feet will be swollen). No high heels allowed or you will not make your meeting due to pain and suffering!

REFUELING
Lots of water to hydrate post-flight. A shot of espresso to perk up.

REPAIRS
Before going to bed on the flight, put on a sheet mask (assuming you don't have anyone next to you who will wake up terrified by your mummified face). Take a sleeping aid of your choice to optimize what few hours you will get. Upon waking, remove the sheet mask. Even though your skin will look gleaming, it's highly recommended you finish things off with some concealer and mascara. And keep your oversized sunglasses on for as long as humanly possible!

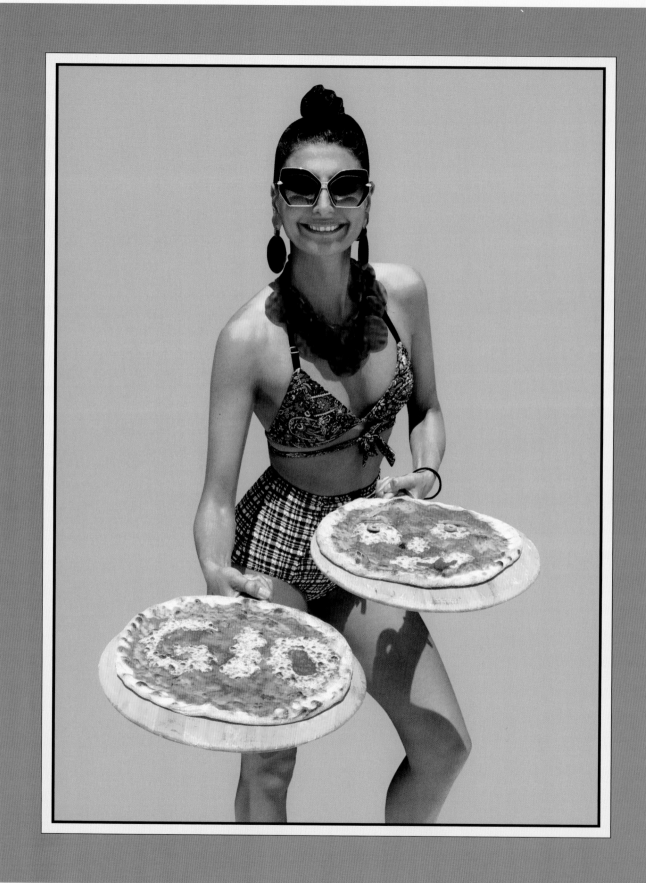

5

EAT DRINK LOVE

33.
GETTING READY APERITIVOS

EAT DRINK LOVE

When you are getting ready for the evening, a pre-outing drink always helps get you in the mood. But there is no one concoction that is the aperitivo version of one size fits all. Different occasions necessitate different preludes.

1. SHOT OF TEQUILA

If I'm super tired and have to rally for an event where I really have to be on, I mix a shot of tequila with some ice—but keep it super small or else it will knock you out!

2. REDBULL

I only resort to this during fashion month when I'm exhausted and I need it before every and any event—even if all I have to do is leave my hotel room to meet someone.

3. ESPRESSO

If you need this before going out, then good luck with your evening!

4. RED WINE

If I'm hosting a few friends, it's nice to have a glass of red wine because it relaxes me and puts me in a homey, cozy mood.

5. VODKA MARTINI

This is my favorite pre-drink when I'm in a hotel because I can't make a good one on my own. Instead, I rely on the expertise of room-service mixology.

6. GLASS OF CHAMPAGNE

I have one before going out to dinner with a friend, because it makes you feel bubbly and happy, but it's not too strong.

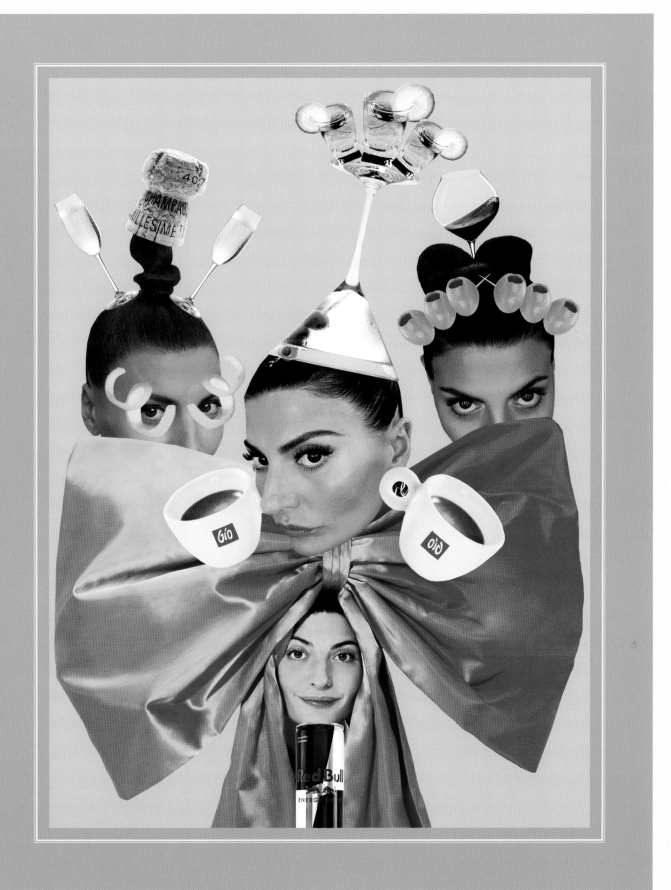

34.
TOP PASTAS OF THE WORLD
(AND ONE RISOTTO)

EAT DRINK LOVE

Federico Fellini's declaration that "life is a combination of magic and pasta" is one of my favorite quotes. Pasta brings people together, creating a sense of family and home. The Italian food company Barilla even has a famous commercial that showcases its pasta, using the motto, translated into English, "Where there is Barilla, there is home." With that in mind, here are some of my favorite "homes" around the world.

SPAGHETTI WESTERN

*Moschino Fashion Show Invitation, Napkin,
Silverware, Boarding Pass on Canvas*

PASTA ALLE MANDORLE OR PASTA FILICUDARA

La Sirena - Filicudi in the Aeolian Islands
Via Pecorini a mare
98050 Filicudi ME, Italy
+39 09 0988 9997
www.pensionelasirena.it

Made with local almonds, this very special pasta is served on an ancient island in a restaurant located in an ultra-low-key harbor that seems like a time capsule from the 1960s. When you eat it, you might feel like Ingrid Bergman in Roberto Rossellini's 1954 film *Viaggio in Italia* (Journey to Italy).

RISOTTO AL SALTO

Antica Trattoria della Pesa
Viale Pasubio, 10
20154 Milan, Italy
+39 02 655 5741
www.anticatrattoriadellapesa.com/en

Imagine Milanese risotto transformed into a crunchy crepe and you have this dish, the epitome of Milanese cuisine. And this restaurant is old-school Milan at its most subtly elegant.

SPAGHETTI ALLA NERANO

Lo Scoglio da Tomasso - Amalfi Coast
Lo Scoglio, Piazza delle Sirene, 15
80061 Massa Lubrense NA, Italy
+39 081 808 1026
www.hotelloscoglio.com

The simplest and chicest pasta, elegant enough to be the favorite of Jackie Kennedy!

PASTA CARBONARA

Pietro Nolita
174 Elizabeth Street
New York, New York 10012
646-998-4999
pietronolita.com

Guilt-free carbonara—thanks to no cream or egg yolks—served, appropriately enough, only on Sundays.

SHORT PASTA IN FRESH TOMATO AND CHILI SAUCE

Elio
2-5-2, Kojimachi
Chiyoda-ku, Tokyo
+81 03 3239 6771
www.elio.co.jp/en/

You can take the Italian out of Milan, but you cannot take the Milan out of an Italian when she's in Tokyo. This dish is the perfect break from classic Japanese fare.

PASTA PESTO

Da Puny - Portofino
Piazza Martiri dell'Olivetta, 5
16034 Portofino GE, Italy
+39 01 8526 9037

Not only is this some of the tastiest pasta on earth, but it's also served in the most photogenic surroundings you will find. It's worthy of its own postcard!

WHITE TRUFFLE PASTA

Hotel Restaurant Salastrains
Via Salastrains, 12
7500 St. Moritz, Switzerland
+41 81 830 07 07
www.salastrains.ch

After a long day of skiing, I advise going face first into a bowl of this.

ROMAN BOLOGNESE

Dal Bolognese - Rome
Piazza del Popolo, 1
00187 Rome, Italy
+39 06 322 2799
www.dalbolognese.it

With the perfect balance of rich meat and earthy tomato flavor, this is the *Bolognese*.

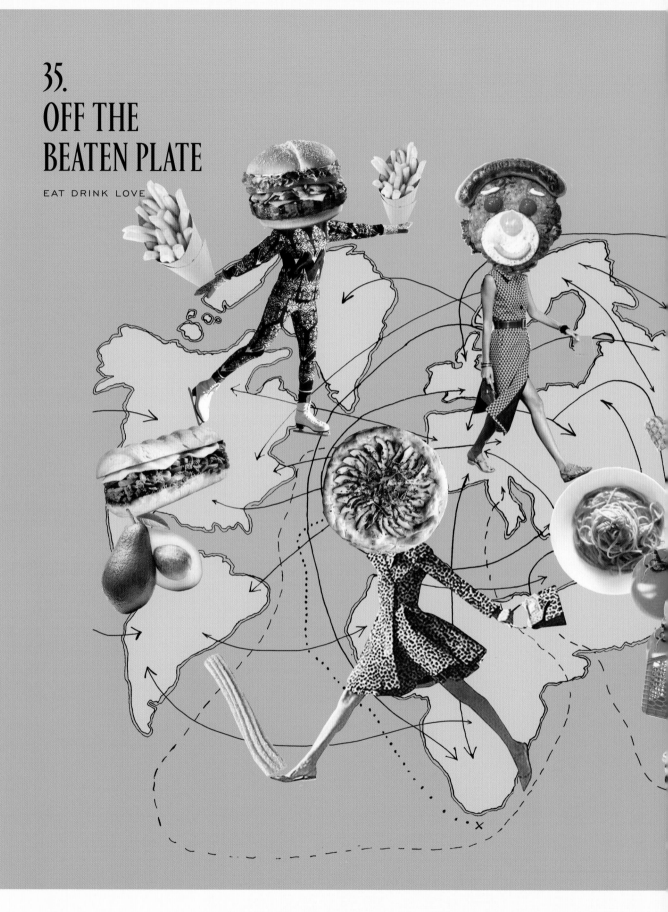

35.
OFF THE
BEATEN PLATE

EAT DRINK LOVE

CHEESEBURGER IN REYKJAVIK

Hamborgarrabúllan Tómasar

In the middle of the capital, next to all the whale-watching tours and fishermen.

PHILLY-STYLE SANDWICHES IN PHILADELPHIA

Tony Luke's

I finally have found the American equivalent of the panini.

CHURROS IN MEXICO CITY

El Moro

I want to eat these by the yard!

AVOCADO PIZZA IN MEXICO CITY

J+G Grill

Just when you think you're good on Instagrammed avocado toast. . .

TEATIME HEART-SHAPED WAFFLES IN SWITZERLAND

Suvretta House

Wear your heart on your plate . . . and eventually your stomach. But it's so worth it.

VIETNAMESE FOOD IN SAINT-TROPEZ

Restaurant BanH-Hoï

Who would think that on the cutest street in the heart of Saint-Tropez, you can find the most delicious Vietnamese food?

36.
FOOD AFTER HOURS

EAT DRINK LOVE

Everything tastes better after midnight. The pleasure of eating after a fun night out is one of life's great joys, especially if you're with friends. And best of all, it will temper the next morning's impending hangover.

JOE'S PIZZA
NEW YORK CITY

211 Eighth Avenue
New York, NY 10011
212-243-3226
www.joespizzaon8th.com

MAROUSH
LONDON

Multiple locations.
www.maroush.com

JIMMY'S GYROS
MYKONOS

Lakka, Mykonos Town
84600, Greece

LE CAPANNELLE
MILAN

Viale Papiniano, 23
20123 Milan, Italy
+39 02 4800 3979
www.ristorantelecapannelle.it

PLACE DES LICES
SAINT-TROPEZ

Food trucks and vendors with french fries, crepes and sandwiches.

PARIS

You're fucked! Best to order room service! (Club sandwich at Le Bristol Paris.)

37.
LE RICETTE DELLA NONNA ROSETTA

EAT DRINK LOVE

In Italy, we say that the best restaurant is always your mom's kitchen. And so it was with my grandmother's.

As an Italian woman, it's one of the oldest traditions that recipes are passed down between mothers and daughters.

My recipes are priceless gifts. I grew up watching her preparing these dishes thinking, "Oh, I'm never going to cook these myself." And then you become an adult and realize you have a treasure trove of riches when it comes to recipes.

FAMILY RECIPES

EAT DRINK LOVE

BRODO

Beef shank or knuckle bones
Chicken wings
Any bits of leg meat left over from butchering
1 celery stalk, chopped
2 carrots, chopped
1 small branch of parsley, chopped
1 potato, chopped
2 ripe pomodorini, chopped
1 onion, chopped
Coarse salt

Submerge beef, chicken wings, and bones in a pot with
plenty of water, and set to boil on high heat. When foam
starts to form on the surface, skim off with a slotted spoon.

Add chopped ingredients and salt. Simmer on low
heat for 3 hours or more. When it's ready, drain the
broth into another pot, and filter again.

To store broth for later use, pour into clean glass jars while
still hot. Let jars cool before storing them in the refrigerator.
To use broth right away, for something such as tortellini in
brodo, set broth to boil, and cook tortellini in it. Serve in the
broth, sprinkled with Parmigiano Reggiano.

RAGÙ NONNA ROSETTA

1 kg (about 2 ¼ lb.) of meat, minced
Olive oil
Garlic, chopped
Handful of fresh basil
2 cans or jars of pureed tomatoes
(De Cecco or Cirio brand),
or your own homemade sauce
Coarse salt

Heat oil in a pot, then add meat. Add garlic as meat begins
to brown, then immediately add a handful of fresh basil.

Cook meat until browned, then pour in tomatoes or tomato
sauce, along with just enough water to wash out the inside
of the jar or can. Add salt.

When the mixture starts to boil, set heat to low, and cook
for at least 1 ½ hours. The ragù is ready when the oil turns
darker in color and rises to the top.

FAMILY RECIPES

EAT DRINK LOVE

ZUCCHINE CON PASTA

Spaghetti
Zucchini
Fine salt
Extra Virgin Olive Oil
Parmigiano Reggiano

Thinly slice the zucchini, place in a strainer, and sprinkle
with fine salt. Set aside for 20 minutes. While the zucchini
rest, set water to boil for the pasta, and cook.

In a frying pan, sauté the salted zucchini in extra virgin
olive oil, until golden brown.

When pasta is cooked, drain and mix with the zucchini in
the frying pan. Serve sprinkled with Parmigiano Reggiano.

POLPETTE

1 lb of lamb, minced
Fresh breadcrumbs
Parmigiano Reggiano
Lots of fresh parsley, finely chopped
Lots of garlic, finely chopped
Pinch of black pepper
Olive oil
3 or 4 eggs
Salt

Place minced beef in a bowl, and add breadcrumbs.
Continue to mix with your hands, as you proceed to add the
rest of the ingredients (Parmigiano Reggiano, parsley, garlic,
black pepper, olive oil, bit of water, eggs, salt).

Once all ingredients are mixed, shape into small balls
with your hands. Fry in extra virgin olive oil.

6

GLOBAL
ENTRY

38.
ODE TO
A TROLLEY

GLOBAL ENTRY

Dearest Mrs. Trolley,

For over a decade, you have been my most loyal of travel companions. I feel I have been remiss in expressing just how much you mean to me. Since the first moment I set eyes on you in London all those years ago, I knew ours would be a love story for the ages. You were sitting there, so sturdy yet so willing to move on your sleek wheels when I needed you. Before we met, I had only known soft, oversized tote bags that weighed down my shoulders, causing me so much pain. You were an immediate palliative to my suffering. I entrusted you with my deepest secrets and possessions: my computer, my jewelry, and my sleeping pills.

I apologize for the premature aging I have caused you with my ceaseless journeys to far-off lands. I see it in the creases of the stickers from different countries with which I cover your frame to mark the passing trips and years. But please know how much joy you bring not just to me, but to all those who encounter you. I see it in the faces of the smiling security guards and fellow passengers who grin at you when you go through security. What a beacon of happiness you are.

I know there will come a day when we will no longer be together. I dread this moment. But it is as inevitable as the changing of the seasons. *Amor mio.* No words can do you justice. I have tried my best. Stay with me just a bit longer.

Love,

Gio

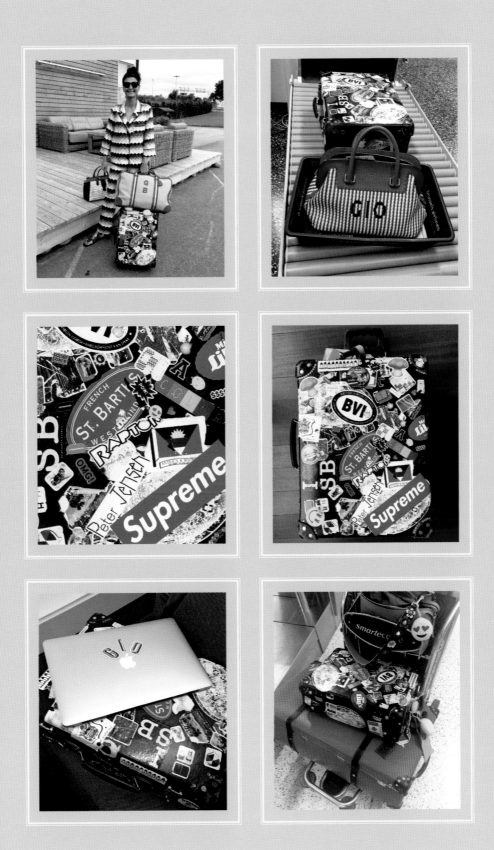

39.
OVER-PACKERS ANONYMOUS

Amid packing for a recent weeklong trip to Europe—a sojourn that usually entails thirty-five outfits—I stood in the doorway to my bedroom and realized that every surface was covered in clothes. I couldn't see the floor, my bed, or any piece of furniture. It was a sea of dresses and tops and skirts (not to mention scattered accessories) in such quantities that I couldn't distinguish one look from another. I had hit rock bottom in my over-packing addiction and after years of denial, it was time to seek help. Like any addiction, recovery doesn't happen overnight.

So here are some hard-earned tips from my many years of struggling with this ailment. YOU ARE NOT ALONE.

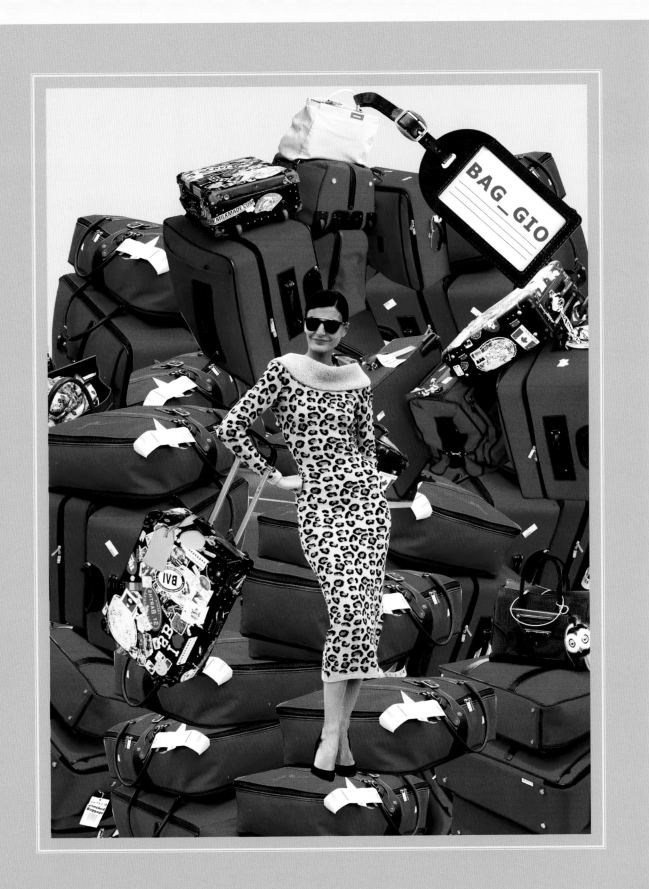

01 If you haven't worn it at some point in the last year, it does not belong in your suitcase.

02 Don't think experience and years of traveling will make you better. Abandon that idea. The truth is it just gets worse.

03 When you are feeling low and are therefore vulnerable to binge packing, repeat to yourself: I am not leaving forever. Take it one journey at a time—eventually you will return home.

04 Consider the consequences: With the amount of money I have spent on overweight luggage, I could probably have bought a private plane. It doesn't matter how big your smile is at the luggage counter, you will pay.

05 Pack in two phases: (1) selection and editing, followed by (2) jumping on the suitcase (or suitcases, plural) to close it shut. If it feels as if you are trying to stuff a double cheeseburger in your mouth, memorize this sensation in great detail in the hopes that it will prevent you from repeating it.

06 Should your trip be a long one with multiple stops, consider a different suitcase or bag for each kind of item—say, shoes in one, elegant clothes in another, coats in yet another, and so forth. This will allow you to access things easily and avoid fully unpacking every suitcase in each hotel. (Though, of course, the easiest thing to do is just ship everything.)

07 When laying items out before they go into your suitcases, try your best to create a clear view of each look. When I'm packing, my room looks like the first day of a sale at Bergdorf Goodman.

08 Be realistic about how much of the contents of your suitcase you will actually wear on the trip. If I go on a seven-day trip, I will probably pack thirty-five things to wear. When all else fails, deny, deny, deny the fact that you have only worn thirty percent of the contents of your luggage at the end of your journey.

09 Take care with delicate items—don't assume that the layers and layers of clothing you have stuffed around them will insulate a breakable or potentially messy item properly. I once packed a huge snow globe without wrapping it and opened my bag on the other end to find it filled with glass, glitter, and water.

10 Of course, the only time you edit out that evening gown you always include but never wear will be the one trip during which you are invited to a very dressy event. It's the law of packing nature. Consider it an opportunity to buy something new out of necessity. Silver lining!

11 If you have a tendency to travel with more suitcases than you can carry, be on the lookout for potential airport Sherpas. I once arrived in Heathrow airport in London for a job with L'Uomo Vogue with twenty suitcases full of clothes for a shoot. There wasn't a porter in sight, so I recruited a football team to lug them outside to my driver. Needless to say, at this point, I have the phone numbers of all the porters in Europe, more or less.

12 At the end of the day, my over-packing stems from the fact that I hate to plan out what I want to wear. I love fashion and prefer to go with the mood of the moment. Hence, I end up with tons of luggage! Be honest with yourself about having an incurable disease from which many others in this world suffer. Don't try to fight it too much. Find a support group and strive for healing and acceptance, not a flat-out cure.

40.
HOW NOT TO MISS
YOUR FLIGHT

GLOBAL ENTRY

As a very frequent flier, one who is often in a rush and operating on zero sleep and crazy jet lag, I am all too familiar with the many obstacles that can come between me and the flight that I so desperately need to make. I have probably missed more airplanes and connections than anyone on the planet by committing every mistake possible! So let me spare you the pain of going through such ordeals by sharing a cheat sheet to the most common travel sins in the hopes that you may reach your destination—unlike me!

-SIN-

I put my computer in a bin to go through the X-ray
machine and someone else picked it up by mistake on
the other side, thinking it was hers. I ended up chasing
said woman through the airport to get it back.

-PENANCE-

Cover my laptop in stickers so no one will ever
mistake it for his or hers again.

-SIN-

I lost my luggage and since it looked like
everyone else's, I couldn't give a very helpful
description to the people trying to find it.

-PENANCE-

Buy exclusively red suitcases so that everyone—
from me to the people working in lost and found—has
the best shot at finding them should they get lost.

-SIN-

Hungover like crazy, I am trying to make an early
flight and I just barely make it to the airport in time . . .
only to discover that said flight has been delayed by five hours.

-PENANCE-

Resolve never to be hungover again on the morning of a flight,
even knowing full well it will totally happen again. Also resolve
to always check for delays before leaving for the airport,
knowing you will probably break this pact, too.

-SIN-

The food on airplanes and airports is terrible
and I'm starving.

-PENANCE-

Some sins are inevitable and just too sad
to discuss further.

-SIN-

Assuming you will always get on a flight,
even if it is overbooked.

-PENANCE-

PRAY.

-SIN-

I am blasting music through my headphones
while sitting in an airport lounge. It's so loud, I don't
hear my flight announcement, and I miss my plane.

-PENANCE-

Learn to wait in silence. It's considered golden for a reason.

-SIN-

I take a sleeping pill just before boarding a flight,
only to find out that the flight has been delayed, forcing
me to function for the next three hours with a soporific
flooding my system.

-PENANCE-

Always wait until the wheels are up
before self-medicating!

-SIN-

I was in Tokyo and super jet-lagged. My flight was
at midnight, but I was so out of it that I showed up to
the airport one day early!

-PENANCE-

Find a non-jet-lagged pair of eyes (for example,
the hotel concierge) to read the ticket, confirming
the actual date and time.

41.
GIO-OUS
NOEL

GLOBAL ENTRY

Marc Jacobs Dress

Christmas is one of those holidays that somehow feels the same no matter what country you're in. I love seeing that yuletide spirit alive and expressed in vastly different places.

WINTER WONDERLAND, LONDON

It looks like an animated cartoon version of a fun fair—
and is the epitome of Christmas spirit and has everything
from sweets to rides, all with a British flair that makes it so
romantic. And you can't do better than being in the middle
of Hyde Park.

SANDHAMNS VÄRDSHUS, SANDHAMN, SWEDEN

This restaurant is practically two hundred years old. It's like
time traveling back to the 1600s. Super tiny, it is total destination
to get there by boat from Stockholm in the middle of winter
crossing the Stockholm archipelago. Once you arrive, you're
greeted with a fireplace and many rooms with low ceilings
and super-classic food. It's a total fairy tale.

CAFÉ POUCHKINE, MOSCOW

At Christmastime, this restaurant, one of the most famous
in Moscow, creates a *Doctor Zhivago*-worthy light cascade.
It's like a crystal palace made of lights.

VIA SAN GREGORIO ARMENO, NAPLES

This street in Naples is devoted exclusively to the most intricate
and elaborate presepi, or Nativity scenes. It's world renowned
for its craft workshop that turns out re-creations of Bethlehem.
The level of detail on their creations is off the charts.

42.
FAVORITE ROOMS AROUND THE WORLD

GLOBAL ENTRY

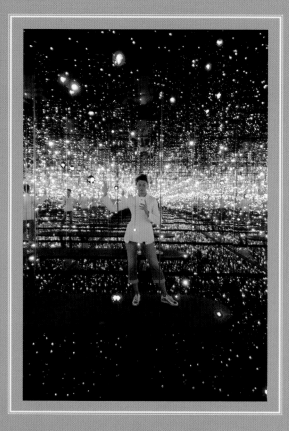

KUSAMA INFINITY ROOM

I used to want to say that I don't want a diamond—
I would prefer a Kusama room. When you enter, it's
truly like stepping into a fantasia that you can't ever
have imagined. And you are so fully immersed that you
forget where you are. In a way, it's better than a vacation
because it's the ultimate escape from the real world.

SALA DEI GIGLI, PALAZZO VECCHIO, FLORENCE

I was at the Palazzo Vecchio for a fashion dinner
and looked up at the ceiling and thought, "Wow,
that goldwork looks just like the embroidery on
a Balmain dress!"

I just love discovering spaces with amazing décor when I'm traveling. Visiting these spaces can be as fulfilling and eye-opening as going to the more famous monuments in your chosen destination. And they make me feel like Alice in Wonderland, wandering through different realms.

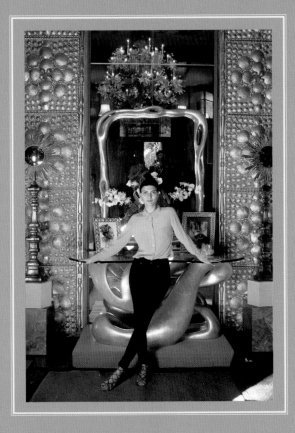

TONY DUQUETTE'S DAWNRIDGE

One of my favorite books is Tony Duquette's tome *More is More*. And there is no better testament to the truth of this statement than the late American artist, designer, and set decorator's exquisite and over-the-top house, Dawnridge, in Beverly Hills.

THE VITTORIALE DEGLI ITALIANI

Gabriele d'Annunzio is a very controversial Italian figure. But I find him utterly fascinating, particularly his home, Vittoriale degli Italiani. Inside the house hangs a painting covered in the slogan "Me ne Strafotto," loosely translated as "I don't give a fuck!"

43.
FAVORITE
HIKES

Hiking is a very recent discovery of mine. I always thought it was a boring thing to do because it's basically just walking. But when I went on my first hike, in St. Barts a few years ago,

I realized it's an amazing way to discover a new place and see sides of it that I would never otherwise know existed.

That's not to say hiking is without its challenges and potential pitfalls! For example, there was the time my boyfriend, now my husband, misjudged how long it would take us to hike on Panarea, and we ended up traipsing around in the dark, using our iPhones for flashlights at three percent battery power, praying that we would make it back alive. That aside, hiking is so much fun to do with someone else: you can talk the whole time and it's a way for me to have a better understanding of nature. It's also the easiest way to gain perspective on things. At first you're just walking along a path, but then when you get to the summit and look around, you realize just how tiny you are compared to everything around you. I'm still not a pro. I always insist on going with someone more experienced and following their lead.

PANAREA, ITALY

The island is so tiny that I thought the hike would be super easy. But suddenly I found myself rock climbing. I had to pass through a rope gate (which must remain closed, so the donkeys that meander in the area don't escape). After starting in Cala Junco (a beautiful bay), I go up the mountain, where there is a panoramic view of all the surrounding islands, and then I head into town.

MUSTIQUE

After driving my golf cart to a point in the middle of a field, I like to walk along the coast of Britannia Bay and then a salt pond. And then I begin to ascend above the mangroves. It starts out rocky and then it turns into a desert. It's like traveling across multiple landscapes.

IBIZA

At sunset, Ibiza is insanely magical: there are lush forests and sculptural rocks, and with the red orange light hitting them, it becomes something totally rich.

SAINT TROPEZ

I know I'm a grown-up person when I'm in Saint Tropez and hiking at eight a.m. instead of being hungover in bed from a party the night before! I can practically walk to another town.

44.
BOAT
FASHION

GLOBAL ENTRY

Growing up, I spent practically every summer sailing with my family. Sometimes we would start at Portofino and go south toward Sicily; other times, we would sail from the Aeolian Islands in the south to Portofino in the north. And it was hardly a luxurious operation: this was a modest-sized sailboat from Cantieri Sangermani, one of the oldest navy yards for sailboats in Italy. Crafted of all wood, it was like an elegant vintage car—and required the same high level of maintenance! So the experience of being on it was less about luxury and more about sport. My siblings and I were both guests and crew members. As a young kid, I was often tasked with wiping down the brass winches. Since the boat was made of mahogany, there was always the danger that the wood would stain, so we were constantly wiping away any salt residue. As I got older, I learned how to steer and would also help my brother Antonio put the sail up the mast—it was a purely manual operation. I learned how to fish on that boat. My record was eighteen tuna in one day!

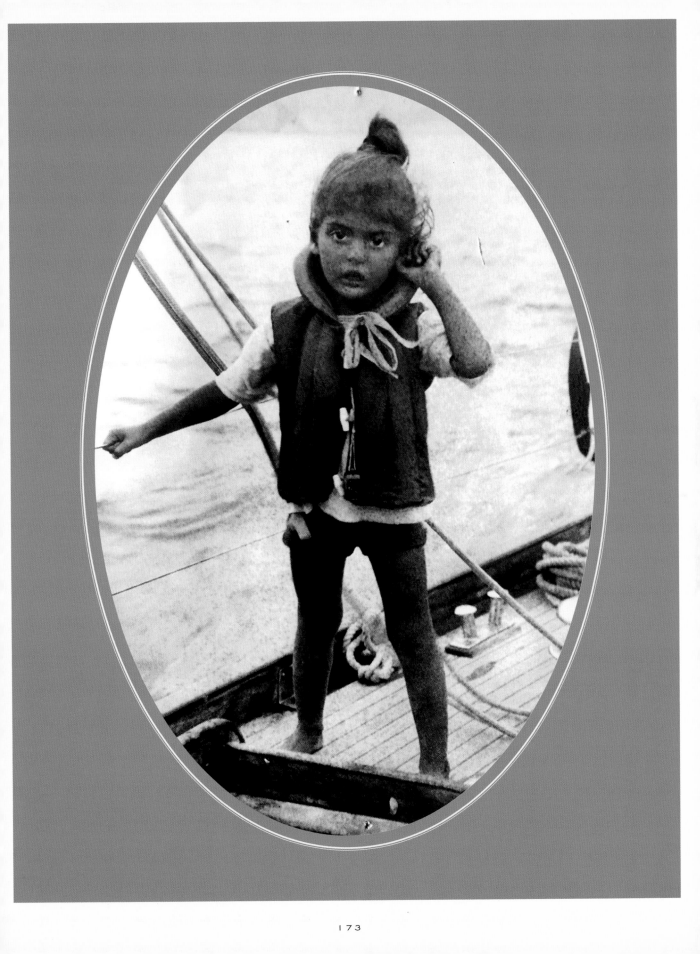

There was one summer when I arrived in Ischia with tendonitis in my wrist because I had been fishing so much. Sometimes, the waters would get very rough or we would get caught in a storm. On such occasions, my mother would hole up below deck clutching the Bible and praying that we would survive. I had a more casual attitude, just saying, "Yeah, it's okay. I can swim!" Being on a boat socializes you because you have to make new friends in every harbor you dock in. It forces you to be more outgoing, which sometimes worked in my favor in ways I couldn't have expected. Once when I was very little, we were in Portofino next to a boat belonging to a famous pharmaceutical family. The matriarch thought I was so cute that she gave me a mechanized toy dog (which was a really big-deal gift for me at the time!). It wasn't until I got much older that I realized all of those summers on a boat, waking up to a different destination every morning, had prepared me for the life of constant travel I have with my job. I have a sense of comfort with impermanence and so I can handle being in ten different countries in two weeks without freaking out. But the ocean is still the place where I feel the calmest. It's my second home. On a boat, I don't feel locked into anything the way I do in a home or room. I'm free to see the world.

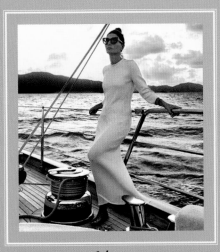

Celine

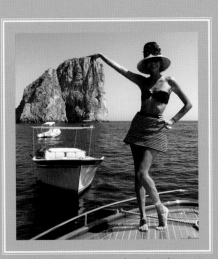

Miu Miu skirt with Kokin hat

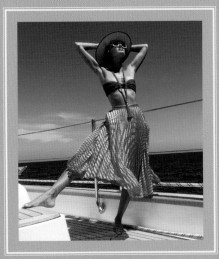

Gucci

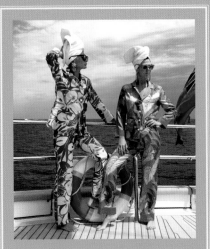

For Restless Sleepers

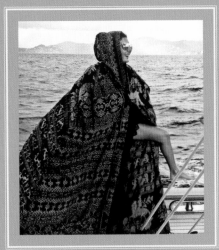

Baja East

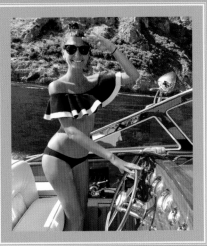

Lisa Marie Fernandez

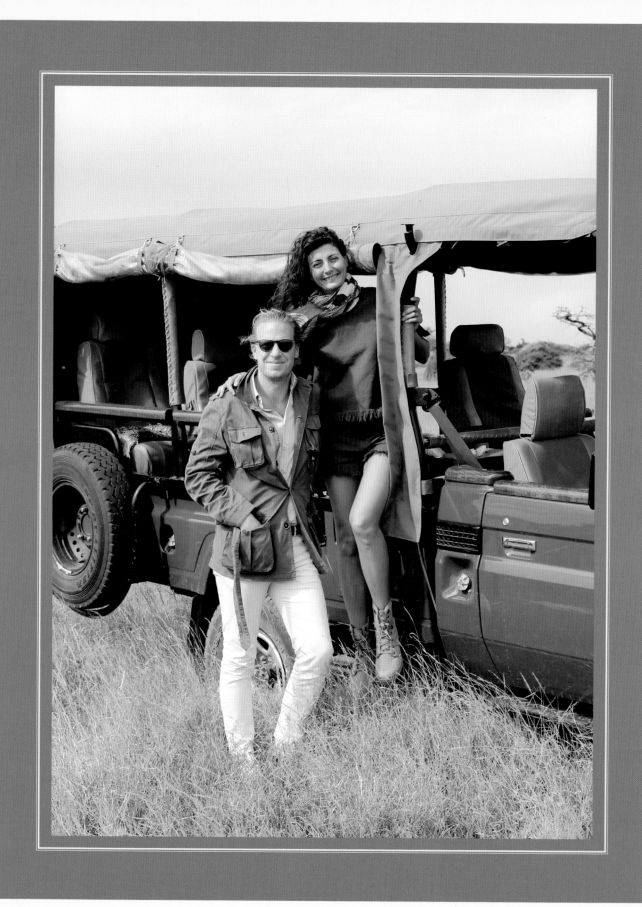

45.
MY BIGGEST ADVENTURE

GLOBAL ENTRY

The most unforgettable vacation of my life was my expedition to Kenya, because it ended up being a surprise engagement trip! My then-boyfriend-now-husband, Oscar, organized the whole thing. We were joining a group of friends, but for the first two days, we were alone.

Oscar is someone who always pushes you to discover and try new adventures.

He is the most enthusiastic person about nature and life and having a good time, and he just loves sharing that with all his friends. It's one of the many things I love about him. Oscar pushed me to a lot of firsts in those two days we were alone. He arranged for us to ride bareback on horses, even swimming on them through an African lake. When I fell off the horse onto a thorny bush, the guide had to pull out the resulting thorns that were stuck in my body. The second day, we rode through a savannah, and clad only in a bikini, my body was soon ravaged by scratches. At one point, the horse, sensing my complete fear, tried unsuccessfully to throw me off his back. At the end of the second day's ride, we arrived at our camp and all I wanted to do was take a hot shower and collapse. "We have to go see the hippos," Oscar said. "I'm done," I replied. "No, we have to go see them," he pressed. "It's so rare and special."

Grudgingly, I agreed. When we arrived at the side of the river lined by hippos, I saw a gorgeous sunset aperitivo set up. And then Oscar proposed. It was a very Lion King situation with all of roaming animals and my un-showered appearance—not exactly how I expected to look during a proposal. But I wouldn't have had it any other way. Travel has been a huge part of our relationship from the start and I hope it always will be. It was only fitting that the beginning of the rest of our lives happened after such an incredible journey. Perhaps those two days of horseback riding were the ultimate test to see if I could survive everything else he had and has in store for me!

46.
FROM GIO
WITH LOVE

"From Kenya with love"

Diana Vreeland famously said "The eye has to travel." I take that sentiment very much to heart: traveling is one of the great joys in my life. And I've always loved the quintessential post card photo shot. There's something so soothingly classic about them. And so wherever I go, I try to create ones for myself, often posing in front of an iconic setting. Usually, they're just for me—but sometimes, I do send one to my mom!

"From Mexico with love"

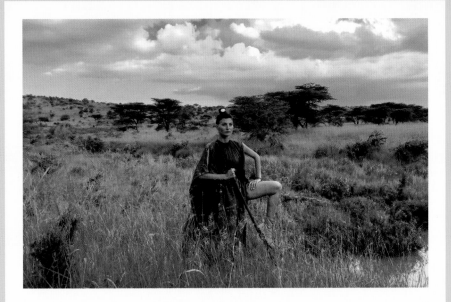

"From the Savannah with love"

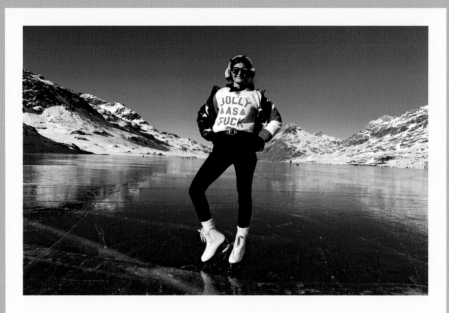

"From Lago Bianco with love"

"From Saint Moritz with love"

"From Maldives with love"

"From Turks and Caicos with love"

"From Santorini with love"

"From Canal Grande with love"

"From Marfa with love"

"From Aspen with love"

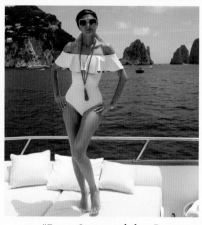

"From Capri with love"

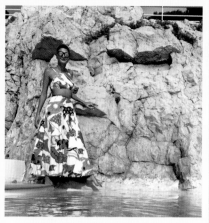

"From Côte d'Azur with love"

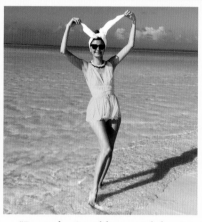

"From the Carribbean with love"

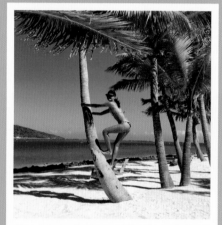

"From British Virgin Islands with love"

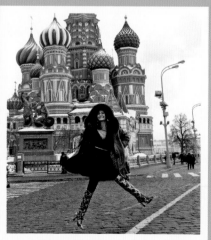

"From Moscow with love"

"From Venice with love"

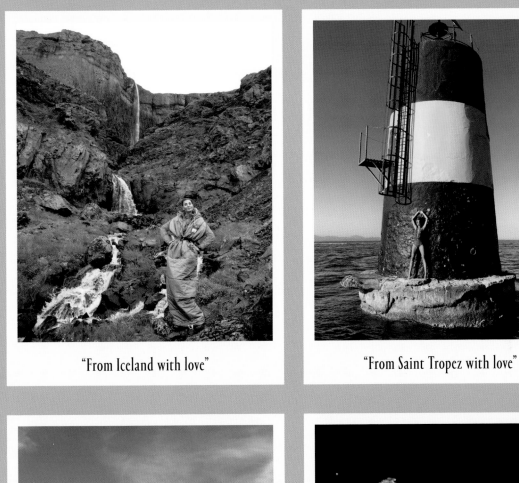

"From Iceland with love"

"From Saint Tropez with love"

"From Rio with love"

"From Las Vegas with love"

PRADA MUSIC JACKS

Prada Label, Polka Dot Fabric,
Various Cable Jacks on Canvas

7

MINI PAINTINGS

47.
ART
THERAPY

MINI PAINTINGS

I used to make mini paintings when I was living in Milan as a visual journal of the places I went to and the experiences I had. They were my take on a scrapbook. They are all rectangular canvases I would create as a way of framing a day or a particular event in my life, often of the nocturnal variety. They weren't for sale—it was always a passion project.

My mini paintings are collages of memories and fantasies.

And I would hang them on the walls of my Milan apartment in a grid format, as a kind of visual diary, which in retrospect is not unlike the Instagram grid on our profile pages. I guess I was ahead of the times!

BONDAGE RUBBER DUCKIES

*Rubber Ducks, Bowtie and
Shoelace on Canvas*

MR. CHOW

*Chopstick Wrapper, Kinder Egg Surprise
Capsules and half a Zebra on Canvas*

SUICIDAL BARBIE

Paper and Faux Vogue Cover on Canvas

FUCK OFF THE FUCKING CUBE

Smashed Rubik's Cube, Acrylic, on Canvas

TABASCO ROCKET

Tabasco Sauce Bottles and Acrylic on Canvas

WOLF OF WALL STREET

*New York Stock Exchange Trading
Tickets and Badge on Canvas*

SARA BY NIGHT

*Sticker Letters and Car Air
Freshener on Canvas*

HOMEMADE CHAMBERLAIN

*Hermes Ribbon and various used
Wrappers on Canvas*

DO NOT DISTURB FENDI

*Purloined Hotel Privacy Door Signs, Fendi
Fashion Show Invite on Canvas*

CHANEL OBSESSION NO. 5

Chanel Perfume Box and Ribbon on Canvas

MINNIE MOUSE INTERSECTION

*Minnie Mouse Heads and Top of
Chanel Compact on Canvas*

1936-2008 YVES SAINT LAURENT

*Sunglasses Circa 2008, Black "Secret Ceremony"
Ribbon, YSL Invite on Canvas*

FREQUENT FLIER

*Old Passport; Green, Silver and Gold Airline
Mileage Cards, Various Coins on Canvas*

HIGHLY DECORATED

Various Medals on Silk Ribbons on Canvas

SMOKING HARMS YOU
(And the people around you)

*Various Table Place Settings, empty
Marlboro Carton on Canvas*

CALL SHEET

*A Talent List from a 2006 Fashion
Shoot, piece of Royal Ribbon on Canvas*

FASHIONISTA

*Sunglasses, Japanese Doll and
Designer Labels on Canvas*

MATCH BOX MOSAIC

Various Matches on Canvas

ALITALIA FRONT ROW

*Marc Jacobs Lipstick Pens, Mini Chairs, Pier
59 Ribbon, Alitalia Boarding Passes on Canvas*

BOARDING, BOARDING

Airplane Ticket Stubs on Canvas

KEN YOU ARE AN IDIOT

Selections From Ken's Wardrobe on Canvas

DISCO BALL RADIO

*Mini Disco Balls, Radio, Keys, Glue, Mirror,
Chanel Nail Polish Tops on Canvas*

IN VITRO BILL

*Test Tube, One Dollar Bill and
Acrylic on Canvas*

MINI VIALS

Various Perfume Samples on Canvas

8

ADVICE FROM
MY FRIENDS

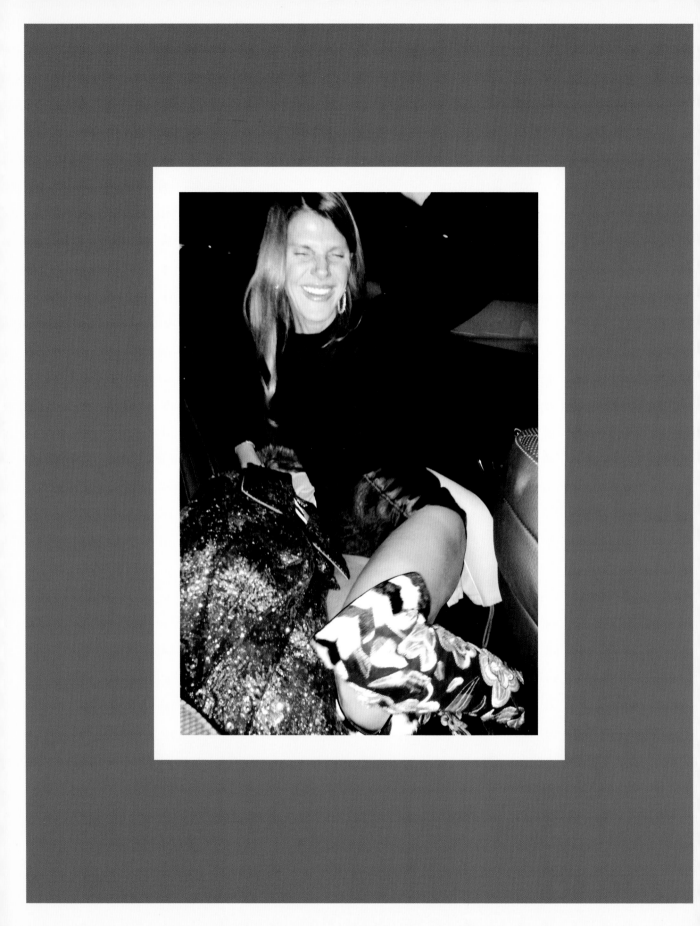

48.
ANNA
DELLO RUSSO

"ENERGY AND A GOOD BODYSUIT ARE KEY"

Anna has been one of my best friends for as long as I've been in this industry. She has more fun with fashion than just about anyone I've ever met—she is full of energy and always willing to take a risk. Over the years, one of the most fun moments of my fashion weeks each season is when I jump into Anna's car to head from one event to another. Why? Because I get to watch her change outfits in a matter of minutes in the back seat. The trick, I have learned, in watching these acrobatic endeavors—thank god she does so much yoga!— is to always have a bodysuit on, to prevent you from inadvertently flashing your driver while slipping in and out of your clothes. I've seen Prada coats turn into Tom Ford gowns, avant-garde Comme des Garçons looks morph into miniature Balmain dresses. Essentially, the back seat of her car is like a highly compressed version of Bergdorf Goodman. And no matter how quick the ride, she always manages to step out on the other side as if emerging from a capacious boudoir.

ARMAND LIMNANDER

ADVICE FROM MY FRIENDS

"THE UNEXPECTED APPROACH"

Armand Limnander, the executive editor of *W*, is not your average fashion industry type. Even though he is very much inside this crazy world, he maintains a different vision: he's at something of a remove, which allows him to come up with clever, outside-the-box takes on fashion and culture. His unorthodox approach brings forth spot-on visual references. There is no better example of this than his "Inspiration Equation," which appears on the last page of *W*. He takes a particularly eccentric look from a fashion show and dissects it into three visual components that together "add" up to the complete look. The twist is that the components in question somehow manage to be completely unexpected yet utterly on point. He might look at a Dior ensemble and say that it was the composite of a woodland nymph, wildflowers, and Franciscan monks! It shows how much fun you can have with fashion when you apply a tongue-in-cheek perspective.

BILL CUNNINGHAM

"IT'S SUPPOSED TO BE FUN"

Bill was the most important guest at any gala in New York. He was a New York City treasure and despite having photographed the party scene for so many decades, he still maintained a childlike wonder and excitement about fashion. Flitting around in his signature blue jacket and khaki pants, his eyes lit up when he spotted a dress or look he loved, as if discovering something for the very first time. It can be hard after a long day or week to get excited about going out, no matter how special the occasion. Being around Bill I learned that not only is it better to be overdressed than underdressed, but also that putting on something wonderfully decadent will lift your mood and therefore the moods of everyone around you. And also that fashion can and should always be a tool for creating a wonderful moment, rather than a burden. Have fun, take a chance, and always maintain a sense of play.

CAROLINA HERRERA

"DON'T BE COOL"

The designer Carolina Herrera is the epitome of chic. I have worked with her on many occasions. The first time I met her, it was in her showroom and I thought, "OMG, she is a Warhol painting come to life!" In those initial five minutes, I was completely intimidated, but once I realized how warm and welcoming and kind she is, I relaxed. Now I think of her as my mentor of elegance, not just in the way I dress, but also in the way I carry myself through the world. During one of our work sessions, we were talking about how everyone in fashion wants to be cool and of the moment. And she said to me, "I hate the word 'cool.' Cool is a word that should only be used for the temperature of drinks. It's better to be elegant than to be cool." Of course, she is right. She leads by example with her unwavering aesthetic that refuses to bend to trends for the sake of attracting attention.

COCO BRANDOLINI

"A SENSE OF SELF IS THE MOST IMPORTANT ACCESSORY"

Coco, for me, is the embodiment of relaxed luxury. She always looks comfortable and low-key, but somehow still expensive, in the best sense of that word. She's the antithesis of pretentious. Though she has access to some of the most amazing couture garments from her grandmother Countess Cristiana Brandolini d'Adda's closet, she also has a knack for picking out the chicest bargain on a flea market shopping spree. But no matter what, whether the dress is priceless or cost ten dollars, she always looks the same because she has such a strong sense of self and style identity. She epitomizes the notion that you wear the clothes, rather than the clothes wearing you.

DEREK
BLASBERG

"TRY TEQUILA"

Once I was super tired from a late night out followed by a long day of work, yet had a very glamorous invitation to a night with Derek at the Met Opera to watch Roberto Bolle dance in the ballet *Romeo and Juliet*. We needed to make sure we would stay up—and on—for the whole night. So Derek suggested that we take a shot of tequila on the rocks before heading out. I was shocked at how awake I felt—it was better than an espresso! I later discovered that tequila, despite being alcoholic, can, in small amounts, feel less like a downer than a stimulant. It's like a more natural Red Bull and vodka, but a hundred times tastier and more efficient. Derek taught me a very important lesson: If you are a bit worse for the wear and need to rally for an important night out, always stick with tequila. In fashion there is an event practically every night, and learning how to boost your mood on a moment's notice is basically a survival mechanism.

GRAZIA D'ANNUNZIO

"LESSONS OF GRAZIA"

Not long after arriving in New York, I was at New York Fashion Week, going from one show to another and I suddenly felt someone grab me by the arm. It was my dear friend, the writer and editor Grazia d'Annunzio. "What are you doing?" she asked me. "I'm taking a taxi," I replied. "No way!" she shot back. And she proceeded to take me on the subway for the first time in my life. Keep in mind, Grazia is the chicest person you will find: there is always something Prada, something Hermès and something Manolo on her. And for the past thirty years, she always takes public transportation. She has a whole technique to it: survival tips, where to stand, all of the usual things. I've also taken a bus with her. And I have to be honest, I sometimes lie to her and tell her I still take public transportation everywhere when in truth, I haven't been on a subway since I last took one with her! I'm afraid to get lost. But she's my mentor, and after she reads this, I'm probably going to have to start taking the subway more regularly! As she has showed me, pragmatism and chic are not mutually exclusive.

HAMISH BOWLES

ADVICE FROM MY FRIENDS

"PASSION IS THE SECRET"

Hamish Bowles is one of the most stylish men in the world. I first saw him at a fashion show when I was twenty-three and had no idea who he was. He was wearing a gold brocade suit and I couldn't take my eyes off him and just thought, "You are so cool." As I've gotten to know and see him through work, I've realized he has the most amazing stamina and attitude of anyone in the fashion industry. I have seen him at an after-party during fashion week, on the dance floor until the small hours, and then I have seen him be the first one at a runway show at nine a.m., fresh as a rose. I have no idea how he does it! But I know what motivates him: ultimate professionalism and a passion for what he does. He approaches his work with an all-consuming love. And through watching him over the years, I've come to understand that you never have an excuse for skipping something interesting and fun. If you love what you do—and the world of fashion is driven by just that—then you can consume every aspect of it to its fullest. It can be an early morning call time or a late-night fete: they merit equal attention and pleasure. And if you're as gracious as Hamish, you do it all with a smile on your face.

LINDA FARGO

"AN ALL-STARS GUIDE TO HEELS"

The women's fashion director of Bergdorf Goodman, Linda Fargo, is known for her unrelenting devotion to high fashion. She will happily don the most outrageous and kooky of outfits and wear them the way most people throw on jeans and a T-shirt. But, of course, fashion and beauty sometimes come with a little bit of pain. Linda taught me that there is no length she won't go to in order to try to make the most uncomfortable of high-heeled shoes work. One evening, she knew she was going to be on her feet all night for an event. Instead of choosing more lenient shoes—as less devoted people would have done—she ordered from room service a bucket of ice. While having her makeup done, she immersed one foot in the ice, while standing, until the sensation became unbearable, and then she would switch feet. That is how you prepare to wear high heels.

LYNSEY ADDARIO

"HOW TO LIVE JOYFULLY NO MATTER WHAT"

On the surface, the war photo-journalist Lynsey Addario shouldn't be the happiest of people. She spends her professional life going to the most ravaged places on the planet and sees horrors I can't imagine. It's one thing to read the news; it's a whole other thing to have somebody who goes out and produces the images we see. But Lynsey is so joyful and excited about everything. She is the most positive person I've ever met. I mean, I complain if I don't have a window seat on a plane. She is completely fine with everything. And she loves what she does, despite how grim it is. If someone like Lynsey can find so much enthusiasm and optimism in life, I have no excuse.

NATALIE MASSENET

"DON'T DUMB DOWN YOUR STYLE"

I was once playing tennis in Kenya with Natalie Massenet, the founder of Net-a-Porter, and a dear friend. She wore a white Chloé dress that made her look as if she were straight out of a painting. That's the way Natalie is: she is always glamorous, but in an easy, unpretentious way. In situations when other people would be wearing super-casual clothes, she still looks elegant, though never overdressed. I've seen her go swimming in the sea with all of her gold jewelry on, including her Tiffany's Elsa Peretti gold bone cuff. And yet, she is also a super-tough businesswoman. Her approach is really about never apologizing for being glamorous—for caring about how you look. Just because the people around you might be in sweatpants, it doesn't mean you have to be. And there is nothing wrong with a tough CEO also paying close attention to how she looks. Fight for glamour if that is who you are.

POPPY DELEVINGNE

ADVICE FROM MY FRIENDS

"HOW TO MAKE AN ENTRANCE"

I first met Poppy a few years ago on a photo shoot, after which we bonded and became the kind of friends who can have not only a crazy night out but also a quiet time in that is full of deep talks about our lives. She is a magnet for fun, and we don't see each other nearly often enough because of our crazy schedules. Once I was in Positano for my good friend Natalie Massenet's birthday party at Villa Tre Ville. The party was in full swing, everyone having a great time, but Poppy was super late—we're talking a couple of hours late. But then when she finally walked in, she had on a fabulous dress (it even matched the tiled interior and the curtains), and she had beautiful hair and makeup and, most importantly, a huge, sparkling smile. She was a human firework. Whatever notice anyone had taken of her late entry disappeared within minutes, and instead, she hit a kind of restart button for the whole event. Without knowing it, she taught me how to be two hours late for a party and still make an entrance!

STEFANO TONCHI

ADVICE FROM MY FRIENDS

"LEAD GENTLY"

I've known Stefano Tonchi since my *L'Uomo Vogue* days when I would run into him during the men's fashion shows. Over the years, our friendship has only grown and deepened. And he has been a real example for me, particularly since he is a fellow Italian forging a career in America. Stefano is probably the most impeccably dressed man I know—he is always in a suit, no matter the occasion. He is also insatiably curious about everything related to the arts, and as a result, is one of the most knowledgeable people I know as well. But what really strikes me is that he is an effortless leader, with an unfailingly kind demeanor. Though he has been editor in chief of the *New York Times' T* magazine and now holds that position at *W*, despite the pressures that come with such high-powered, stressful jobs, he has always had a gentility to him. Coming to America, I thought you needed to be a scary or tough on the outside to be a boss—Stefano proves there's a chance for kind people to be in charge.

ACKNOWLEDGMENTS

For anyone who loves gorgeous books as much as I do, having the chance to make one with Rizzoli is nothing less than a dream. Thank you Charles Miers, who had the idea for this book. Caitlin Leffel, your clear-headed guidance charted my course through *Gio_graphy*. Giovanni Bianco, *ti adoro*. I am so grateful to you, Francisco Tellechea, Lauren Goldblum, Cheyanne Proud, and everyone else on the design team. Thank you Inez van Lamsweerde and Vinoodh Matadin for shooting such a beautiful introductory photo that is a portrait of my inner spirit.

There are many people without whom this book would not exist, among them Chenelle Croll, Elena Lakomkina, Emma Grede, Mecca James-Williams, and Carlotta Tabaroni (for your charming collages).

Vanessa Lawrence, thank you for making my voice come to life—I will miss our many FaceTime hours. To my beloved assistant, Kelsey Leahy, a master of organization and patience who devoted so much to this book.

Growing up, my mother Maria Vincenza gave me the most stable and healthy foundation, allowing me to act out my wildest dreams without ever losing my footing. My sister, Sara, and brothers, Antonio and Luigi, are the most fun and funny and best people I know. I love you all.

And to all my friends, old friends, new friends, and those who are no longer my friends—you all have contributed to making me who I am today.

Finally, to my husband, Oscar Engelbert, you have always embraced my craziness, encouraging me to be myself while keeping me grounded. And our wedding was the most joyful day of my life, but that will have to be another story . . .

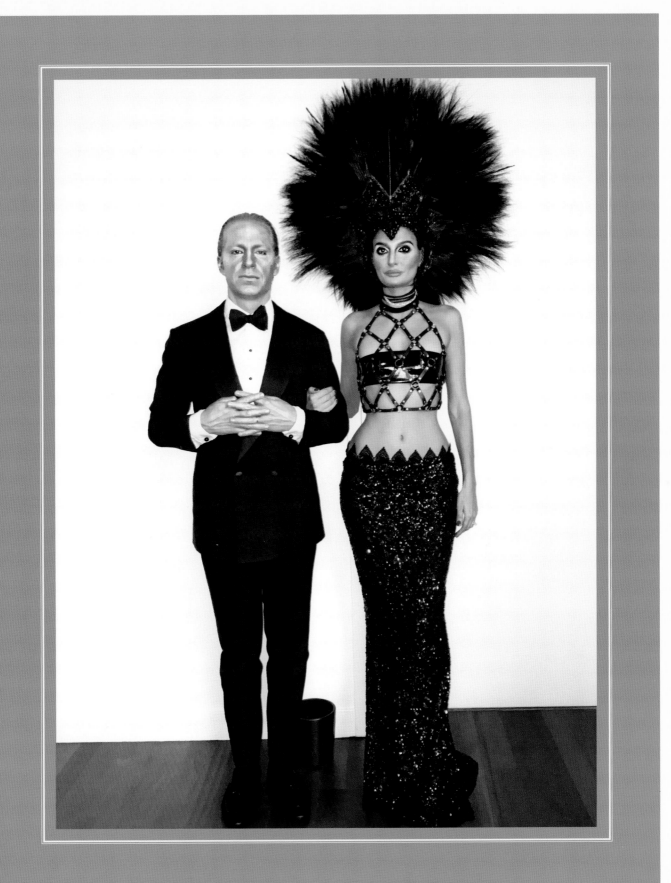

CREDITS

First published in the United States of America in 2017
by Rizzoli International Publications, Inc.
300 Park Avenue South, New York, NY 10010
www.rizzoliusa.com

CREATIVE DIRECTION: Giovanni Bianco, GB65
ART DIRECTION: Lauren Goldblum, GB65
GRAPHIC DESIGN: Cheyanne Proud, GB65
CREATIVE COORDINATION: Francisco Tellechea, GB65
RIZZOLI EDITOR: Caitlin Leffel
EDITORIAL ASSISTANCE: Kayleigh Jankowski and Irina Lutsenko
TEXT: Vanessa Lawrence

2018 2019 2020 / 10 9 8 7 6 5 4 3 2

Distributed in the U.S trade by Random House, New York
Printed in China

ISBN: 978-0-8478-5839-2

Library of Congress Control Number: 2017947883